The 1980s: Prints from the Collection of Joshua P. Smith

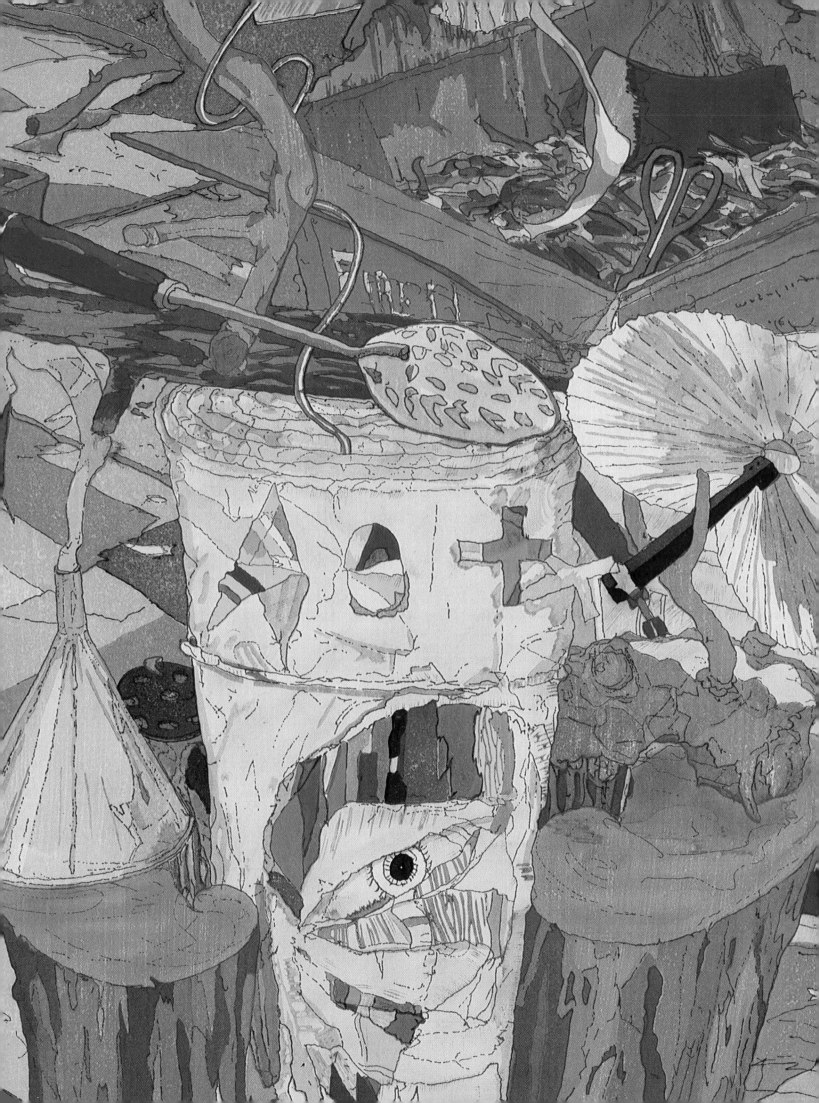

The 1980s
Prints from the Collection of Joshua P. Smith

RUTH E. FINE
Editor

Catalogue by Charles M. Ritchie
with assistance from Thomas Coolsen

National Gallery of Art
Washington

The 1980s: Prints from the Collection of Joshua P. Smith
National Gallery of Art, Washington
December 17, 1989–April 8, 1990

This book was produced by the editors office, National Gallery of Art. Editor-in-Chief, Frances P. Smyth. Designed by Stephen Kraft. Typeset by BG Composition, Inc., Baltimore, in Frutiger. Printed by Schneidereith & Sons, Baltimore, on 80 lb. LOE Dull text.

Front and Back Covers: Jennifer Bartlett, *Shadow*, 1984

Frontispiece: William T. Wiley, *Eerie Grotto? Okini* (detail), 1982

Library of Congress Cataloging-in-Publication Data

The 1980s: Prints from the collection of Joshua P. Smith/Ruth E. Fine, editor; catalogue by Charles M. Ritchie with assistance from Thomas Coolsen.

 p. cm.

Catalogue of an exhibition held at the National Gallery of Art. Includes bibliographical references.
ISBN 0-89468-142-7

1. Prints, American—Exhibitions.　2. Prints—20th century—United States—Exhibitions.　3. Smith, Joshua P.—Art collections—Exhibitions.　4. Prints—Private collections—Washington (D.C.)—Exhibitions.　I. Fine, Ruth, 1941–　II. Ritchie, Charles M.　III. Coolsen, Thomas.　IV. National Gallery of Art (U.S.)

NE508.A18 1989
769.9'048'074753—dc20　　　　　　　　89-14053
　　　　　　　　　　　　　　　　　　　　CIP

Contents

Foreword

Throughout the 1980s, important artists of great diversity have created major works of art in printmaking. They have worked in many corners of the world, some of them alone in their studios, but most of them in concert with expert printers, often in elaborately equipped printmaking workshops. In their etchings, lithographs, screenprints, woodcuts, monoprints, and multi-media prints of every possible variety, these artists have explored the central artistic concerns of our time, responding to nature in all of its aspects as well as to conceptual and formalist challenges.

During this time, which coincides roughly with the first decade of its East Building, the National Gallery of Art has undertaken an expanded program of collecting and exhibiting contemporary art. As part of this program, we have placed an important emphasis on prints and drawings. An expansive archive from the Gemini G.E.L. workshop in Los Angeles has been donated by its owners, Sidney B. Felsen and Stanley Grinstein. An archive collection from Graphicstudio, at the University of South Florida in Tampa, has also been donated, as an outgrowth of the enthusiastic vision of its director, Donald J. Saff. We appreciate as well the support of the many talented artists who have undertaken projects with these workshops.

These crucial archive gifts have greatly augmented our holdings of contemporary works on paper that have come to the Gallery from a variety of other donors. First among these were prints and drawings given by Lessing J. Rosenwald. To them were added donations from many others, including Lee V. and John L. Eastman, David Gensburg, Mr. and Mrs. Burton J. Tremaine, Mr. and Mrs. Roger P. Sonnabend, Dorothy J. and Benjamin B. Smith, Mr. and Mrs. William Speiller, Dr. and Mrs. Maclyn E. Wade, June

Wayne, and The Woodward Foundation, Washington, D.C. In addition, the Gallery expects many gifts of contemporary prints and drawings in the future, such as the important examples collected by Robert and Jane Meyerhoff.

Among the continuing supporters of our efforts in the realm of contemporary prints has been Joshua P. Smith, a long-time Washington resident who resigned from his post with the Department of Energy to devote himself full time to art, especially to his work as an independent curator. Mr. Smith has generously shared with all of us at the National Gallery his passionate interest in photography, in early twentieth-century American prints and drawings, and in the art of the 1980s. He has made generous gifts to our collection over several years.

Given the breadth and importance of Mr. Smith's contemporary holdings, we were delighted when he agreed to share this selection with the public, following suggestions expressed both by Andrew Robison, senior curator and curator of prints and drawings, and Ruth E. Fine, curator of modern prints and drawings. Ruth Fine ably selected the exhibition and coordinated the catalogue, with assistance from Charles M. Ritchie and Tom Coolsen.

All of us at the National Gallery of Art are grateful to the artists, printers, and publishers for their role in producing the works on view, and to Joshua Smith for his foresight in forming a collection of the first rank which he has so generously agreed to make available to our visitors. We are delighted to enter the last decade of the twentieth century with such a splendid selection of contemporary prints.

J. Carter Brown
Director

Acknowledgments

The organization of every exhibition has its unique pleasures. With this, the most distinctive enjoyment has come from working with Joshua P. Smith. Throughout the years in which I have been following the growth of his splendid collection he and I have been engaged in a continuing dialogue about art (not only prints, but photographs, paintings, drawings, and sculpture as well). His informed enthusiasm for the work of the period has been a model of inspiration. I also thank him warmly for his important contributions to the growth of our collection.

We owe a great debt of thanks to the artists, printers, and publishers who conceived, accomplished, and supported the challenging group of prints in this exhibition. We are grateful not only for the work on view, but also for the help they provided by supplying information during the course of our research. We thank the following artists for providing information about their work: Ida Applebroog, Mel Bochner, Gregory Crane, Martha Diamond, Aaron Fink, Michael Heindorff, Roger Herman, Paul Marcus, George McNeil, Melissa Meyer, Richard Mock, Jürgen Partenheimer, and Troels Wörsel.

We would also like to thank the staff at the following galleries and print workshops: Brooke Alexander, Inc.; Alpha Gallery; Pamela Auchincloss Gallery; Baron/Boisanté Editions; David Beitzel Gallery, Inc.; Blum Helman Gallery Inc.; Mary Boone; Grace Borgenicht Gallery; Brody's Gallery; Robert Brown Contemporary Art; Galerie Buchmann; Carini Editori; Fabian Carlsson; Leo Castelli Gallery; Castelli Graphics; Joseph Chowning Gallery; A Clean, Well-Lighted Place; Paula Cooper Gallery; Crown Point Press; Dart Gallery; Davis & Langdale Company, Inc.; John Davis Gallery; Delano Greenidge Editions; Derrière L'Etoile Studios; Dolan/Maxwell Gallery; André Emmerich Gallery; Echo Press; R. C. Erpf Gallery; Experimental Workshop; Exit Art; Joe Fawbush Editions; Ronald Feldman Fine Arts, Inc.; Fendrick Gallery; Vincent Fitz Gerald & Company; Galerie Six Friedrich; Georg Olms Verlag; Barbara Gladstone Gallery; Gracie Mansion Gallery; Graham Modern; The Grenfell Press; Harlan & Weaver Intaglio; Liz Harris Gallery; Jane Haslem Gallery; Galerie Hermeyer; Hirschl & Adler Modern; Hudson River Editions; Bernard Jacobson Ltd.; Galerie Fred Jahn; Michael Klein, Inc.; M. Knoedler & Co., Inc., B. R. Kornblatt Gallery; Barbara Krakow Gallery; Alfred Kren; Galerie Krinzinger; Editions Ilene Kurtz; Lieberman and Saul Gallery; Marian Locks Gallery; Lorence-Monk Gallery; Luhring Augustine Gallery; Curt Marcus Gallery; Marlborough Gallery, Inc.; Marsha Mateyka Gallery; Maximilian Verlag-Sabine Knust; David McKee Gallery; Metro Pictures; Middendorf Gallery; Robert Miller Gallery; M-13 Gallery; Multiples, Inc./Marian Goodman Gallery; Victoria Munroe Gallery; John Nichols Gallery; David Nolan; Pace Editions, Inc.; The Pace Gallery; Parasol Press; Pelavin Editions; Petersburg Press, Inc.; P.P.O.W.; Produzentengalerie; Margarete Roeder Gallery and Editions; Ronin Gallery; J. Rosenthal Fine Arts, Ltd.; Mary Ryan Gallery; Betsy Senior Contemporary Prints; 724 Prints, Inc.; Tony Shafrazi Gallery; The Sharpe Gallery; Simmelink/Sukimoto Editions; Solo Press; Sonnabend Gallery; Sorkin Gallery; Sperone Westwater; Studio Cavalieri; Thompson Gallery; Edward Thorp Gallery; Barbara Toll Fine Arts; Garner Tullis; Tyler Graphics Ltd.; Universal Limited Art Editions, Inc.; Bertha Urdang Gallery; Vermillion Editions Ltd.; Diane Villani Editions; The Vinalhaven Press; Washburn Gallery; Zabriskie Gallery, and the Zolla/Lieberman Gallery.

Other colleagues who have been helpful include Elizabeth Armstrong, Walker Art Center; May Castleberry, Library Fellows of the Whitney Museum of American Art; Sue Welsh Reed, Museum of Fine Arts, Boston; Robert E. Stein of Special Papers Inc.; and Andrew Stevens, Elvehjem Museum of Art.

Many National Gallery staff members have worked closely on this project. We have all enjoyed the enthusiastic support of J. Carter Brown, director; Roger Mandle, deputy director; John Wilmerding, former deputy director; and Andrew Robison, curator of prints and drawings. Charles M. Ritchie, assistant curator of prints and drawings, and Tom Coolsen, departmental secretary, have worked tirelessly, both on the catalogue and on other details of the exhibition. They have been supported by other members of the department staff, including assistant curator Carlotta Owens and exhibitions assistants Ben Glenn II and Mary Lee Corlett. The conservation department has been of enormous assistance and support, particularly matter-framers Hugh Phibbs, Virginia Ritchie, and Jamie Stout, as well as Shelley Fletcher, Pia DeSantis Pell, and Mark Stevenson.

D. Dodge Thompson, curator for exhibitions, and Heather Reed have coordinated exhibition matters. Anne Halpern, associate registrar, with great expertise and good humor has coordinated the problems of shipping and storing prints of great size and fragility. Editor-in-chief Frances Smyth has closely overseen the production of this

catalogue with the assistance of Chris Vogel, handsomely designed by Stephen Kraft, with editorial work by Ben Reiss. Also of assistance have been Neal T. Turtell, chief librarian, and staff members Ted Dalziel, Thomas McGill, Jr., Roberta Geier, Lamia Doumato and Ariadne DuBasky. Richard Amt, chief of photographic services, and Dean Beasom, William Wilson, Desiree Miller, Philip Charles, José Naranjo, Rick Carafelli and Ed Owen have masterfully completed the necessary photography. Ira Bartfield, coordinator of photography, assisted by Barbara Bernard and Margaret Cooley, and William Taylor, slide librarian, assisted by Thomas O'Callaghan and Nicholas Martin, have been supportive as well. Christopher With, Gretchen Hirschauer, Diane DeGrazia, Sally Metzler and Elise V. H. Ferber have helped with translations.

The exhibition has been designed and installed under the enthusiastic guidance of Gaillard Ravenel, head of our installation and design department, with important contributions from Mark Leithauser (one of whose etchings is among the prints on view), Gordon Anson, William Bowser, Barbara Keyes, Gloria Randolph, Theresa Rodgers and Jeffrey Wilson. The other members of this department as well as our marvelous team of art handlers, under the guidance of John Poliszuk, are among the unsung heroes of all our exhibition installations.

The great enthusiasm of Genevra Higginson, assistant to the director for Special Events, and her staff; Ruth E. Kaplan, Deborah Ziska and Ann Diamonstein of our public relations office; Elizabeth A. C. Weil of our corporate relations office; and Ysabel Lightner of our publications department have all contributed greatly to the realization of this project. I am also indebted to Larry Day's patience and intelligence.

REF

Prints of the 1980s: A Dialogue

Ruth E. Fine and Joshua P. Smith

Ruth Fine: By 1980 you had been collecting American prints of the early twentieth century for close to a decade. What happened to shift your interest to contemporary prints?[1]

Joshua Smith: At the start of the 1980s, I had only a few recent prints in my collection, but I had a strong grounding in what I thought good prints were. All of a sudden, as the eighties came on, I entered the contemporary art world through prints, just as I had come into the earlier art world through prints. I sort of leap-frogged several decades—I went from the forties right into the eighties.

RF: When you say you had a grounding in what good prints were, what are you talking about—technically, or . . .?[2]

JS: Technically, aesthetically; I knew about different media, and what a good impression was, what a successful print was in terms of carrying out the artist's message, whether it be abstract or representational, that sort of thing.

RF: You once talked about being interested in prints that had a specific kind of message. This would lead me to believe that you were interested in representational imagery at first, and that at a certain time you broadened your scope of interest. Was this the case?

JS: I began my collecting in the eighties with representational prints, expressive prints, often with a narrative nature. As the decade progressed, however, I didn't switch, but I became more interested in abstract prints. The eighties was a period when two other things happened in my collecting. First, I focused on contemporary as opposed to earlier prints, and second, I went international, acquiring not only American prints but also substantial numbers of works by European artists.

RF: Do you remember which were the first prints you bought from the period? And having bought those prints, did you actually make a decision to build a specific kind of collection, or did the momentum evolve more intuitively?

JS: I remember seeing Richard Bosman's paintings at the first Awards in the Visual Arts exhibition at the National Museum of American Art.[3] I found them sort of interesting, but then I went to see his woodcuts, and I remember being absolutely blown away. I wasn't thinking of collecting, I just was looking. I wasn't a gallery goer or museum goer interested in contemporary art, and I hadn't really been exposed to either contemporary painting or contemporary prints. So Bosman is special to me. I own a number

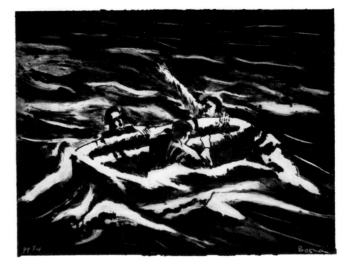

1. Richard Bosman, *Life Raft*, 1984, carborundum etching on Rives BFK paper, 21³/4 x 29³/8 (55.2 x 74.7)

of his prints (see fig. 1 and cats. 18 and 19); he was one of the artists who got me involved with contemporary art. I like the idea that at that time he was not one of the most major names. This coincided with the start of the woodcut revival of the early eighties and the concurrent interest in a new figurative expressionism.

RF: When you started collecting prints of the eighties, did you buy in Washington, or was going to New York an important part of the pattern of your life and your interest in contemporary art?

JS: I did find myself going to New York quite often, at first for family reasons. But I soon got into a pattern of seeing gallery and museum exhibits and meeting people in the art community at openings and elsewhere. I had never had much contact with living artists. My excitement was stimulated immediately by viewing a lot of the imagery, and by seeing the highly energized art scene of New York—the idea of New York as one of the centers of an emerging international scene; a reawakening of an interest in painting; the return to representation—all of the clichés that everyone talks about. It seemed to hit from all directions; and I found it irresistible. This is not to say that I have bought everything in New York. I got a fair number of things in Washington, and as time passed in various other cities to which I traveled—Basel, Munich, Hamburg, Lon-

don, Los Angeles, Chicago, Milwaukee. And also by phone and by mail. But the energy of the international scene, the European artists, the young artists, the pulse of the eighties was really felt in New York.

RF: Your branching out from collecting only American art reflects the larger print world of the eighties. This has been a period of much greater awareness in this country of what was happening in Europe.

JS: Exactly. At first this was seen primarily through painting; but probably because I had been a print collector, I saw it first through prints.

RF: Throughout this period you have acquired works in other media—paintings, sculpture, drawings—but you have remained basically a print collector. Prints tend to be less expensive than paintings, but I suspect there's something about the nature of prints that interests you quite apart from the economic issues.

JS: I like the physical properties of prints: the feel of paper and the sensual way ink adheres to it. Woodblock prints first caught my attention in the early eighties—the Bosmans, as I mentioned before, and also Louisa Chase's woodcuts such as *Squall* (fig. 2). There is something wonderful about that soft oriental paper often used for woodcuts, for example, in Francesco Clemente's self-portraits, *I*

2. Louisa Chase, *Squall*, 1983, woodcut on Okawara paper, image: 30 x 39½ (76.2 x 110.3)

and *Untitled* (cats. 27, 28), and that strong, saturated color that sometimes bleeds right through the paper. The expressive representational work that has been done has really lent itself to the woodcut medium, for example the landscapes of the German artist Bernd Zimmer (cat. 119). Later, I got interested in the more abstract prints, many of which are etchings or other forms of intaglio—works such as the overpainted *Untitled (Burnt Yellow)* (cat. 15) by Mel Bochner; the geometry of Al Held's *Straits of Magellan* (cat. 53); and also the work of Donald Sultan. Sultan works to great effect with rich black and whites, in both the early hard-edged prints like *Smokers* and the softer *Black Lemons* (cats. 109, 110). I think his use of aquatint is extraordinarily lush. It is ironic how even given the multiple process, his printed images seem more lively and vibrant to me than his drawings of similar subjects.

RF: These etchings, then, have specific "printerly" as opposed to painterly qualities?

JS: It has to do with the inextricable link of form and media in these etchings—the composition and the bite. And in all of the media there is a certain strong graphic quality that printmaking has; there's often a view of the image as it fits on the page. I have an interest in reading the page, even with such large works as the Sultans.

RF: There's also a sense of intimacy that is possible despite the large size. Prints are more readily handled than paintings; if they are unframed one tends to lay prints down on a table and lean over them, making direct connections that I think generate very different experiences than one has with paintings.

JS: Also, there isn't the same distancing mystique as there is with painting. I like the immediacy, a feeling of a certain freshness.

RF: There is less an issue in contemporary prints of worrying about the quality of impression than there is with earlier prints. Prints from professional workshops are usually checked by the printers or publishers for consistency, and there is minimal variation from impression to impression. When artists do their own printing, they often are interested specifically in varying their impressions, as seen in the work of some of the Europeans in your collection. This allows the collector the possibility of comparing the various impressions to find the most interesting ones. Indeed,

3. Richard Diebenkorn, *Spreading Spade*, 1981, aquatint, spit-bite, and drypoint on Arches Satine paper, image: 17⁷/₈ x 18¹⁵/₁₆ (45.4 x 48.1)

collectors often seek out the unique image, the one that is different from the edition, or the image with special hand-coloring. Ironically, in being interested in prints—works that one thinks of as being made in multiple—one often seeks out the unique objects among them. I wonder to what extent you focused on acquiring them.

JS: While I do like the uniformly well-crafted prints from the larger, long-established workshops—for example, Richard Diebenkorn's *Spreading Spade* from Crown Point Press (fig. 3), and prints from Gemini G.E.L., Petersburg Press, Tyler Graphics, Universal Limited Art Editions—I have a special inclination either specifically to seek out or, if I find them by chance, to acquire works that have something special about them. Examples in the exhibition include the four *Landscape* proofs by Baselitz and the overpainted impression of his *Reading Man* (cats. 6–10). The proofs were done in 1980, but it's not clear from looking at them whether they're studies for other works or finished works in themselves. I am especially interested in prints that have that sort of immediacy of the artist's intention as evident in this rough, tactile sense that lets you feel that printmak-

ing has been put to its full test. It's especially true with the works by Baselitz. Even though he does editions, most of his individual prints, until recently, have been slightly varied. Particularly when they are proofs or trial proofs, the stages in which the prints are developed or worked on—the different states, or different impressions—are fascinating.

I'm especially interested in seeing a related group to compare them, and to see the progression, for technical, and especially, for aesthetic reasons. Take Jörg Immendorff's monumental *consequences* from the Café Deutschland series (cat. 59)—it must be one of the top ten prints of the decade and is remarkable in many respects. It's huge. It was made in ten different versions, with variations of each version. He put paint on them without worrying about conservation issues or whether the paint would adhere properly or not; he even walked all over them. That's one aspect of the artistic process made visible in a full-blown way; and for me, with all its imperfections, that kind of work is often more meaningful than a more pristine print. The Mühlheimer Freiheit artists, Walter Dahn and Jiri Georg Dokoupil (cats. 32, 37), are both admirers of Joseph Beuys, Gerhard Richter, and Sigmar Polke.[4] They have worked together on certain pieces, have had their works exhibited together, and they change their styles every year or so. The screenprint by Dahn in the show (cat. 32) is made on plain packing paper. Gustav Kluge and Felix Droese (cats. 68, 69; 38–40), also Germans, print their own prints, in very small editions or as unique objects. I discovered them all in Europe a few years ago. In their work each impression is very different from the others (see especially cats. 38–40), often on different papers—tissue papers, wrapping paper, newsprint, cardboard, in different colors of ink, printed with different variations in the pressure, and sometimes variations even in the imagery itself.

RF: The artists you have been mentioning all seem to be Germans.

JS: One of the things that attracts me to many of the German prints is this kind of personal involvement, and the development of process, the symbiotic growth of the image as it varies; as it's printed on different papers and with slight variations in the imagery.

RF: To make a technical distinction, those prints would be called monoprints, one-of-a-kind images printed from a plate or block or stone that actually could have been used for an edition if the artist wanted to do so. Perhaps a similar impulse on the part of artists in the United States has more often taken the form of the monotype, prints in which the image is drawn or painted or otherwise worked onto a flat surface, usually metal or glass, from which it is then transferred onto paper. Only one impression is possible although there may be a ghost image.[5]

JS: Right. Examples of monotypes in the show would be *S.P. 1/9/85 A*, the self-portrait by Michael Mazur, one of a whole series of monotype self-portraits; *Windows* by Martha Diamond; Gregory Crane's *Greg's Yard (The Little Houses)*; and *Untitled (Woman)* by Mary Frank (cats. 78, 33, 29, 47). Frank is a sculptor, and it seems to me that a sculptural quality comes out in her monotype, too. I think works on paper by sculptors have the physicality of sculpture translated into a special physicality in printmaking. I have a number of other monotypes, too, for example, Ford Crull's *Revelation's Door* (fig. 4). I think it's true that the Americans have been more involved with monotypes, whereas the Europeans are more involved in monoprints, in varying their impressions from the plates and blocks.

RF: But there are monoprints in the exhibition by Americans, too—for example, Susan Rothenberg's *Pinks* and Joan Snyder's *Mommy Why?* (cats. 95 and 103). We've talked about artists whose approach to both imagery and process is radically varied. The decade of the seventies has been referred to again and again as the pluralist decade.[6] Do you have a phrase for the eighties?

JS: I prefer to call the eighties rather than the seventies the pluralist decade. I think in some ways the seventies could be tracked rather easily, in sequential movements, whereas the eighties truly are more pluralist—lots of things are going on simultaneously and vigorously.

RF: You talked earlier about the pulse of the eighties—is there really such a thing, or are there multiple pulses?

JS: There are multiple pulses. There have been many things driving the eighties: there were new artists added to major galleries for the first time in many years; galleries were formed that were very influential; there were many new contemporary art collectors; many artists came here

4. Ford Crull, *Revelation's Door*, 1986, monoprint on Rives BFK, image: 18 x 14 (45.6 x 35.5)

from Europe. Whatever you can say about the seventies, it was a rather quiet time. A lot of the art was introspective. Much of it was conceptual and environmental. A lot of artists shunned the idea of the art market. There wasn't the explosive enthusiasm and interest that was generated in the eighties when there was a real force—an energy. The East Village art scene came and went. People were hungry for art to play some part in their lives, whether they were producing it or consuming it, or in some other way participating in art activities. The artists themselves wanted visibility—wanted to become known. Collectors and institutions wanted to have visible impact. There was something going on that turned the quiet, closed circles of the seventies into the more public, assertive, energetic groups of the eighties, with a desire to make art important, something that the community in general took notice of.

RF: But it's still a very limited society you're talking about.

JS: That is true. But in the sixties and seventies, generally, the blockbuster exhibitions had to do with antiquities or the old masters; in the eighties they often had to do with contemporary art. More museum goers went to see contemporary exhibits, and there was a higher profile for contemporary art. Prints played a large role in this expansion.

RF: Let's get back to the subject of prints per se. It seems to me that in the second half of the decade you got to know a lot of artists and printers. I wonder how that extended your interest in prints.

JS: I think what happened can best be explained by the fact that I wasn't only interested in well-made editions by major publishers; I was also interested in works that were more personally made, often in smaller editions, by smaller publishers like Diane Villani, who has worked with a number of printers, or printer/publishers such as Judith Solodkin.[7] And I got to know certain publishers—and their printers.

RF: Did you get to know the printers through the publishers?

JS: Sometimes through the publishers; sometimes I met printers just by chance. This started to happen about mid-decade. Some printers would refer me to other printers. Getting to know printers wasn't just a matter of obtaining prints. Sometimes I went to printers' shops and didn't buy any prints at all. But there was a certain fascination in being where the prints were made; seeing what people were working on, what they had done before, seeing who dropped in to do some work. The exposure to the printers, and the general experience and the knowledge gained and the enjoyment obtained were more importan to me than the total number of prints acquired from printers, which actually was not that great.

RF: Which printers have you had personal contacts with?

JS: Donna Shulman, Jamie Miller, Cheryl Pelavin, Don Sheridan, Paul Marcus, Felix Harlan and Carol Weaver, Chip Elwell, who died tragically a few years ago—he was a wonderful woodblock printer and a wonderful person to talk with—Doris Simmelink, Jane Kent, Betty Winkler, Yong Soon Min, and Leslie Miller of the Grenfell Press,

who worked on the David Storey book, *A Beehive Arranged on Humane Principles*, written by Gilbert Sorrentino (cat. 108).

RF: The Grenfell Press also published Peter Cole's *Rift*, with two of Joel Shapiro's woodcuts (cat. 102). To change the subject, you once told me how much you had learned about prints of the 1920s and 1930s from dealers such as Antoinette Kraushaar and Carole Pesner of her gallery, Gertrude Dennis of the Weyhe Gallery, and Stephen Long and Sylvan Cole, who at that time was at Associated American Artists. Is it the case that with this next generation you learned instead from the printers, by picking their brains? You must have learned a lot while you were absorbing the atmosphere and getting the kind of knowledge you can only get by being in the workshop.

JS: I learned a lot about the prints of the eighties from dealers too. But I would say that being with the printers is a lot like being with the artists. I need to see the whole process to understand who I like or what the final product really is. If you go to a printer's workshop, you can see all of the things he or she is working on, all of the things he or she has produced earlier—you can see a whole variety of things by several artists, different versions of things, special proofs. It's not a matter of the mechanics of how they make a print. It's the aesthetic idea. It's interesting to see one printmaker who works with many different artists—you get a picture of what the general atmosphere is, of what that printer contributes to the projects. You can see the variations in the ways particular artists work with different printers. I then feel I am part of the process; I don't feel I'm just a consumer. I feel I can figure things out with greater depth because I can understand the nature of the creation of a work of art.

RF: This also is a reinforcement of an interest in what is possible only with prints. Because of the workshop situation, it may be possible to see aspects of the artistic process usually not accessible in studying paintings unless you are in an artist's studio as he or she is working.

JS: Yes, I guess in that way the print shop can be a fairly public place.

RF: I'd like to talk about what followed your excitement in seeing Richard Bosman's woodcuts. In some instances, as with Bosman, you have many works by an artist; in others

you have only one. When you have only one work by an artist, are you consciously trying to get the archetypal work of that artist?

JS: No. I don't actually try to get any particular works by any artist—I don't make a list, fill in things I'm missing, and so forth. I tend to be pretty impulsive.

RF: Who else were you interested in early on?

JS: The earliest work I was interested in generally was that of the figurative neo-expressionists—both in the United States and Europe.

RF: Rothenberg, Bosman, Baselitz, Penck, Chia, Cucchi. Did you see this new figuration as having any kind of loaded political, social meaning or stance?

JS: No. It was just powerful imagery. Although some artists, for example Richard Mock in a print like *Hoof Man* (cat. 82), clearly suggested political content.

RF: In thinking about your interest in both photography and printmaking, and given that you have just organized the exhibition *The Photography of Invention: American Pictures of the 1980s* for the National Museum of American Art, I wonder if you see parallels between the photographs and prints of the eighties that would reinforce our idea of what the eighties primarily have been about.[8]

JS: Clearly in the area of appropriation of images and styles there are overlaps—the kind of appropriation that exists in contemporary art in general, for example in the work of David Salle. He, of course, appropriates actual photographs, as in the lithograph from *Theme for an Aztec Moralist* (cat. 98); and I would say that the appropriation and layering of imagery that he uses is not only specific to his work, but a more common thread within the period.

RF: Some artists have made the point that they never had a drawing class in art school. The camera then becomes a drafting tool, as in the phrase "the pencil of nature," suggesting the idea that you could do a drawing without a pencil.[9] I guess we've gone full circle.

JS: Frankly, I think this is an interesting area—the whole idea of how an image gets made, whether it be by a camera or by a pen or pencil, or collage, or by a printmaker. It's

pretty fascinating that you can "draft" through the use of the camera; the substitution of the camera for drawing has applied to certain kinds of photo-etching, photo-silkscreen, even photo-lithography.

RF: Starting, say, with Andy Warhol or Robert Rauschenberg, there has been a great interest in photo-printmaking—the use of photographic images as well as photographic processes.

JS: Sure, but in the late sixties and early seventies what you had, both in terms of photography and printmaking, was a lot more basic technical experimentation.

RF: But certainly today photographic techniques are used constantly for practical reasons as well as aesthetic.[10]

JS: But the emphasis today is primarily on the content of the appropriated photographic imagery. Although technical experimentation is interesting, I find it sterile compared to full-fledged appropriation—unabashed thievery, not just exploiting technical processes. One other thing—there's also a correlation between photography and printmaking when it comes to size: the fact that they've both gotten bigger.

RF: Prints have been big for a long time. Remember that *Oversize Prints* exhibition at the Whitney in 1971?[11]

JS: True, but prints are generally larger today whereas then, big prints were the exceptions. Several of the largest works in this show are the ones by Immendorff, Herman (cats. 59, 54). . .

RF: Stephen Campbell's *The Hiker Said, "Death You Shall Not Take the Child"* (cat. 21).

JS: The Campbell is definitely noteworthy for its size. Campbell is an artist who makes very, very large paintings and who, in turning to printmaking, needed to work in a comparable size. He cut the block himself, having never done a print before. He cut into a big piece of wood that he found, and since he didn't have any experience printing he called on Chip Elwell. It is on more than one piece of paper, but it's from one block of wood. I saw the massive block in Chip Elwell's studio, somewhat warped.

RF: It's actually on six pieces of paper. They're joined three and three and function as two vertical panels.

JS: Anyway, this is not a "big prints" show; it's a print show,

but these large pieces are typical of a lot of very large prints that are being done.

RF: Let's not forget Hermann Nitsch's *The Last Supper*, a highly innovative mixed media screenprint on canvas (cat. 87). It is worth mentioning, too, that Nitsch, an Austrian, works primarily in performance, rather than painting or sculpture. The point here, though, is that it's impossible to have a show of prints of this period without including representative prints of large size. At the same time, there's no reason now to have a ''big prints'' show because that point was made a long time ago. It's important to keep in mind, too, that many of the prints in your collection are quite small.

JS: Of course. There are many wonderful images on a small scale—Altoon Sultan's *Picking Grapes* (fig. 5) and Per Kirkeby's *Prototyper* (cat. 67); Bill Jensen's portfolio *Endless* and Jürgen Partenheimer's *Book of Wanderings* (cats. 61, 89). All of these demonstrate that large size isn't essential to visual power. The whole question of prints holding the wall in competition with paintings—I don't know that you can say these intimate things hold the wall in that sense, but they seem equally substantial. Anyway, since I've mentioned Partenheimer, I should read you part of a letter he wrote to me about his *Book of Wanderings*:

The book was made during my stay in San Francisco in 1983, but the idea for the book existed long before, yet it received a last

5. Altoon Sultan, *Picking Grapes*, 1983, drypoint, image: 2⁷/₈ x 4⁵/₈ (7.3 x 11.9)

important push when I looked at some exquisite Carolingian book covers at the Metropolitan Museum in New York. The idea to make a contemporary ''book of hours'' i.e. ''imaginary wanderings'' also in a mythological sense (Ulysses) became so strong that I started to draw, collect drawings and designed a cover, which alludes to the religious as well as to the profane content of the idea of meditation.[12]

RF: We have been talking about the pulses of our time, and have touched upon the importance of appropriation and the issue of size. What would you say other important issues are? I'm thinking about relationships between some of the younger people in the exhibition and artists who are more established, such as Richard Diebenkorn, Robert Rauschenberg, George McNeil, Malcolm Morley, and, of course, the late Philip Guston. There are generational separations even among these more mature artists, but what do these artists exemplify, if anything? How do they influence, or if not influence, what are the affinities—to use current jargon—between them and the younger generation?

JS: I think there are very clear connections, without doubt. In certain cases, younger artists have talked to me about who and what interests them. Eric Fischl told me he is directly influenced by Max Beckmann and Edward Hopper and by the photographers Edward Weston and George Platt Lynes. I was very lucky to get his *Year of the Drowned Dog* (cat. 45). I happened to be at an exhibition of the portfolio and some of the proofs, and the publisher agreed to sell me some of the proofs that were not for sale; soon after, by pure coincidence, I located a copy of the portfolio, so I had both the proofs and the final product. It's a wonderful example of the new figurative expressionism; the use of narrative that is complex and ambiguous; a work in multiple overlapping parts. It is interesting how much Fischl depends upon photographic imagery, and part of my attraction to his work has been based in this. I mentioned Salle earlier. I believe he has some relationship to the German artist Sigmar Polke. It's not only appropriation and combining images that's important, but, as with Polke and Rauschenberg, it's actually taking photographic imagery and appropriating it. I think there are strong connections between several of the younger artists in the show and Rauschenberg.

RF: Keep in mind that for more than a decade, Rauschenberg

essentially has used his own photographs rather than appropriating others'. Should we discuss an affinity, if not influence, between George McNeil and the apocalyptic vision of Philip Guston's late work and that of the younger artists?

JS: Michael Hafftka, for example, has told me of his appreciation for their work. It is noteworthy that at exhibits of Guston and McNeil during the eighties, people would wander in, and if they didn't know the work, they'd think it was the show of a young East Village artist. The spirited imagery of McNeil's art and Guston's late work is similar to that of many younger artists. Also influential is Guston's seemingly crude and childlike drawing style.

RF: To continue this line of thought, where do you place Stella?

JS: I think a lot of the neo-geometric work and abstract work of today generally follows strongly on the early Stella. The work of Sean Scully, for example (cat. 100). Stella in some sense has to influence anybody who does abstract work.

RF: Well, one also has to consider the very different direction of Ellsworth Kelly's abstraction, as seen in *Concorde II (State)* (cat. 66). But as far as Stella goes, there's also a kind of flamboyance in his recent work—as seen in *Shards IV* (cat. 107)—that surely has had its effect on non-abstract artists as well.

JS: And technical virtuosity—in the instances when artists use the print workshops, they have access to and often take advantage of all of the facilities of the workshops, potentially leading to both artistic flamboyance and technical virtuosity.

RF: Once I selected the works from your collection for this exhibition, some things seemed to fall into categories that have to do with subject, some to fall into categories that have to do with style, some don't seem to want to be categorized at all. Expressive figuration has been one of the major categories. Portraiture became an offshoot of that, for example Alex Katz' *The Green Cap* (cat. 65), which in its cool sleekness sets up an enormous contrast to the more expressionist works like Antonius Höckelmann's *Head* (cat. 56), which really borders on the surreal. Myth became another offshoot, for example Sandro Chia's *Fish Bearer* (cat. 26).

JS: Yes. Chia is a strong new expressionist, going back to earlier times in his reference to the mythic—you can feel the European weight of the past. We in the United States seem more tied to the media and pop culture than the Europeans, who are more closely tied to history, myth, and religion.

RF: Partly because they are surrounded by the "Old World" and also because of differences in various educational systems, I suppose.

JS: *Fish Bearer* was printed in New York and published in Europe; and as far as I know it wasn't distributed in this country. It shows that the international print market works in many ways—while some things are available all over the world, some things that are made in one place are only available in another. Even though prints are multiples, some of them are unlikely to be available or seen in the United States.

RF: Of course Donald Baechler's work suggests other international issues.

JS: Baechler lived and studied in Germany and his work relates to that of the Cologne artists in the exhibition, Walter Dahn and Georg Dokoupil, and their predecessors and teachers. Although most of his prints have been done in New York, the prints on view, in fact, were undertaken while Baechler was in Europe for an exhibition. He was in Vienna and worked with the renowned printer Kurt Zein. Another aspect of the eighties is this increased internationalism with artists traveling frequently for exhibitions.

RF: And while away from home they often make prints at workshops in specific cities.

JS: Aaron Fink, whose *Blue Smoker* is in the show as well as his portfolio *Perhaps* (cats. 43, 44), has shown a lot in Germany, perhaps an indication that the sensibility that I'm interested in is of interest abroad. Donald Baechler shows much more in Europe than in the United States. But to get back to the idea of myth, Enzo Cucchi, like Chia and other Italian artists, is involved with myth and other references, including religion.

RF: To continue with our discussion of categories, social commentary could also be one. It would include Chris Burden's *The Atomic Alphabet* (cat. 20), for example. And we

could make image appropriation a category, or use the rubrics of neo-geo, or biomorphism—I'm not sure there is a comprehensive logic within which an organization falls into place.

JS: One of the reasons I think this decade is more pluralistic than the seventies is that it's hard to put things into categories and periods. I think it's even harder to do this with prints than with paintings. There is something—and that's what makes the prints so fascinating—where the subject and technique—the markings—distinctively interact, for example in Jake Berthot's two tiny untitled etchings (cats. 12, 13), or Glenn Goldberg's *Coil Print* (cat. 48), which is extremely spare, or the incredible line in Sol LeWitt's screenprint *All one, two, three, four, five and six-part combinations of Six Geometric Figures* (fig. 6). I think it's been a wonderful decade for prints. I love the prints of the seventies, especially the spare, minimalist prints. But with the eighties, I'd be hard-pressed to say which ones I like the best, or how I'd characterize them. I feel the energy of the eighties, even though it's often attributed to a return to painting, really includes the riches of printmaking.

RF: It's difficult to name a major painter or sculptor who hasn't participated in printmaking, and not with small projects either, but with major, ambitious endeavors.

JS: Painters and sculptors increasingly entered into printmaking in the sixties and made it a more profound art form; but I think in the eighties we have the harvest of that. Not only are mature artists making prints, but emerging artists are anxious to make prints, too, if they are given an opportunity.

RF: It is important, too, that not only did a number of the artists in the exhibition start to make prints during the eighties, but also that a number of the printers and publishers represented in the show started their activities and others became far more vigorous and vital in the print field during this decade as well. The printers have made creative contributions. They come from printers introducing artists to certain processes they'd not used before; they also come from the printers encouraging different artists to do printmaking of any sort for the first time.

JS: I've met a number of the people who run these small shops and have talked with them about how they approached artists and convinced them to do their first

6. Sol LeWitt, *All one, two, three, four, five, and six-part combinations of Six Geometric Figures*, 1980, screenprint on Rives BFK paper, image: 64$\frac{1}{2}$ x 37$\frac{5}{8}$ (163.8 x 94.8)

prints or to do prints in a different medium. There's a constant dialogue going on between the publishers, the printers, and the artists.

RF: You have closely followed Mark Baron's publishing, for example. He seems to have done a variety of kinds of projects. Can we use him to demonstrate how the publishing process might work?

JS: I've known Mark since I bought his first portfolio. He wanted to do prints, had no background academically or otherwise in prints, yet he read books and asked questions, and worked with artists and began to collect their work. He'd worked in art galleries. For his first portfolio, he worked with the artist Michael Hafftka, who generally does his own printing, as he did in his later project, *Overtones* (cat. 51). Hafftka's main influence is Anton Heyboer, a Dutch artist. Like Heyboer, Michael is passionate about the way he prints. Just about everything he does tends to be done in a unique form; even when they're intended to be editions, he gets carried away. He puts all of his energies into printmaking. He's usually making images of himself or his family. Anyway, Mark Baron quit his job and started working at print-publishing on a full-time basis. When he ran into some problems printing a Michael

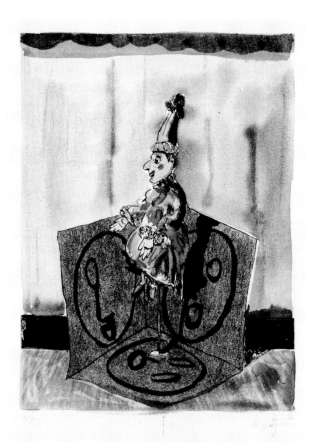

7. **Michael Byron, one print from** *Players*, **1986, etching with painted additions on German Etching paper, 11⅞ x 8⅞ (30.2 x 22.6)**

Byron portfolio (fig. 7), he went to printer Donna Shulman to get some technical help, and then he hired her to finish the work. She since has printed other things for him, for example Not Vital's *Snowblind* (cat. 113), which is a very special piece.

RF: Do you want to talk about it?

JS: Well, Not Vital is a sculptor, but this work specifically was conceived to be completely separate from his sculpture. He wanted it to be solely a print project, unlike earlier prints which were related to his sculpture. His manner of hanging the several parts on the wall is crucial, too, suggesting the importance of the arrangement. But to return to Mark Baron, he's an individual with particular aesthetic insight who has a hunger to work closely with emerging artists, who gets the artist together with the printer and then sees the project through, publishing a small edition. He tries to do things that wouldn't be of interest to a larger organization. There are many other small-scale publishers in New York and in fact around the country who do similar things. Mark's work exemplifies the tendency in the eighties toward doing portfolios.

RF: During the years that the Tamarind Lithography Workshop was in Los Angeles, in the 1960s, they produced a number of portfolios.[13]

JS: The concept of doing portfolios obviously goes back well before Tamarind, but it seems to me that today there is a distinctive tendency in that direction. I don't know if this has any validity, but maybe with so many big prints, it's harder for small prints to have the same sense of value unless they're in a group as part of a portfolio. Otherwise they might get lost.

RF: There's an insistence about a portfolio that a single small print may not have. A portfolio also serves the notion of series; and there seems to be a renewed interest in narrative which is well served by that format.

JS: For example, T. L. Solien's *Fragments of Hope* (cat. 104), a narrative that relates to the loss of the artist's son. It's so beautifully put in both symbolic and representational fashion—very touching, and quite different from his large-scale color prints such as *Untitled* (fig. 8). I particularly like portfolios and works in series, an integrated work in which all of the pieces have a connection, one to the other.

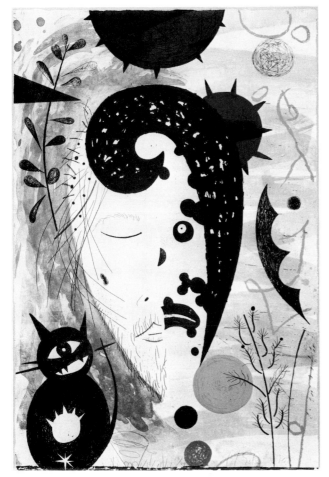

8. T. L. Solien, *Head of a King*, 1986, etching, aquatint, lithograph, woodcut, and screenprint on Velin Arches, 35½ x 23¾ (90.2 x 60.3)

RF: In a very different vein is the extraordinary group of aquatints by James Turrell, *Deep Sky* (cat. 111), related to his Roden Crater project in the Arizona desert.

JS: They're very much about light, the sort of a light that can only be experienced at that specific location.

RF: It's best appreciated as a unit, with the temporal aspects of the seven prints working together.

JS: I like the process of opening and closing a portfolio—the ritual of handling it. I prefer paging through a work as opposed to seeing it hung on the wall. We talked earlier about the intimacy of the image on a printed page, and in a book or portfolio, there is a special allure.

RF: *Deep Sky* is one of several marvelous portfolios of prints by both American and European artists that have been published by Peter Blum. Among the several that you have acquired, in addition to Turrell's and Eric Fischl's *Year of the Drowned Dog,* is Brice Marden's *Etchings to Rexroth* (cat. 77).

JS: Yes. It's a very complex sequence, and Peter Blum told me that it took a long time for Marden to decide on the proper organization of the plates.

RF: You have also been interested in the Whitney Museum of American Art library's book publishing project for some years and have a number of the books they have issued, don't you?

JS: I have the Vija Celmins book [Czeslaw Milosz' *The View* (cat. 24)]. Celmins' work intrigues me because she achieves such a degree of perfection by her obsessiveness. The intensity of the production of the art is felt in the final product; besides which, the works are absolutely beautiful.

RF: We're also showing one of her individual prints, *Constellation-Uccello* (cat. 23).

JS: Among the other Whitney publications that I have are those by Eric Fischl [*Annie, Gwen, Lilly, Pam and Tulip* by Jamaica Kincaid], and Richard Tuttle [*Hiddenness* by Mei-mei Berssenbrugge] (cats. 46, 112). I've always bought books, but mainly artists' books, fairly inexpensive offset editions that one could get at places like Printed Matter in New York or Bookworks, the W.P.A. [Washington Project for the Arts] bookstore in Washington. My acquisition of books with original prints, in any substantial number, although I don't have that many, started in the eighties.

RF: In the last decade there has been a much greater interest in finely printed books than there was, say, in 1977, when William Matheson and I did an exhibition of American letterpress printing for the Grolier Club in New York.[14] I think the only printer in this exhibition from your collection who was in that one is Andrew Hoyem, who owns Arion Press and published *Wallace Stevens: Poems* (cat. 62) with a small version of one of Jasper Johns' beautiful Seasons prints for a frontispiece.

JS: There is a lot of interest in that area, but I haven't fol-

lowed it closely. I did get interested in Vincent Fitz Gerald's publications, for example Mark Beard's *Neo-Classik Comix* (cat. 11). Beard is an idiosyncratic artist who has done several books with Fitz Gerald. The quality of the production of the whole project is important, not just the work of the artist: the subject of the volume, the design of the book, and both the artist's and the publisher's sensitivity to the whole entity. I would say that my way of collecting books presents a good example of my collecting in general. I have a sort of aesthetic barometer; and while at times I'll focus on a particular artist or publisher or kind of work, it's not the result of great planning.

RF: You seem accidentally, then, to have discovered most of what has been happening during this recent period. You have collected a number of drawings associated with prints, too—for example Immendorff's "Kein Licht für Wen?" from *erste konzentration* and the related gouache study (figs. 9, 10).

JS: I make a practice, not necessarily to look for, but to get, when I see them, drawings related to prints if I come across them and like them. I like to have the prints as well, and having the drawings adds another dimension.

RF: Let's talk specifically about some of the other artists and prints in the show. How did you learn about the work of Roger Herman, for example, who works in Los Angeles?

JS: Herman moved to Los Angeles from Germany, and his work came to my attention at the time that other neo-expressionist work was being done, but it was really different. It had not just monumentality, but a special kind of roughness. I think he's interested in largeness as an aesthetic factor. He makes gigantic prints because he understands what big means. I think the size of the works makes for their power, not just by being big but by hitting us with the unexpectedness of their size. I think Herman's intentional crudity is very important. I had seen reproductions of his large prints such as *Fieldwork* (fig. 11). I acquired them on the basis of seeing slides—unusual for me.

RF: Did you find it difficult to make a selection on that basis?

JS: The surface qualities of prints and photographs are very difficult to judge in slides. I find it more difficult to judge them from slides than I do paintings.

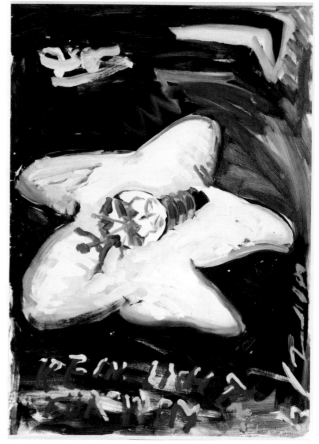

9. Jorg Immendorff, *Kein Licht für wen?, (No light for whom?)* 1981, gouache on wove paper, 40¹/₁₆ x 28¹¹/₁₆ (101.7 x 72.9)

RF: I find everything difficult to judge in slides. Herman's *Mask* (cat. 54), though, has both printed and painted surfaces. A hand-painted proof, an important aspect of it has to do not only with the vigor of the cutting into the wood and the especially thick layer of ink, but also the painting that followed. The visibility of the hand, the layers of the work, the sense of how it was made, is very different in effect from what is seen, for example, in the two *Men in the Cities* prints by Robert Longo (cats. 72, 73).

JS: With Longo's work there is a sense of the artist being opposed to the presence of an expressionist hand. He works from photographs of friends, and the work conveys a sense of a moment caught, moving through time in a certain stylized manner. The prints express the urban angst of his generation in a very graphic way. There's a

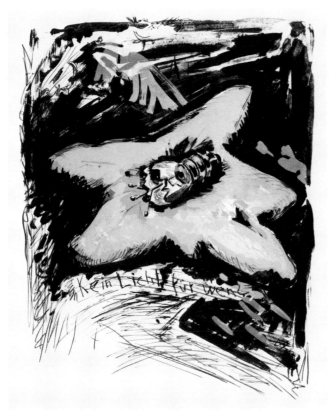

10. Jorg Immendorff, *Kein Licht für wen?, (No light for whom?)* from *Erste Konzentration (First Concentration),* 1982, lithograph on Velin Arches, image: 27¼ x 21¾ (69.2 x 55.2) irregular

special elegance in his use of black on black, on top of the elegance of the sleek imagery.

RF: The importance of gesture comes in the overall scheme of the form rather than, as in the Herman, in the overall handwriting. How would you place the sense of fragmentation in Jonathan Borofsky's work?

JS: Borofsky, too, is expressionistic, sometimes in an almost playful way. *Stick Man* (cat. 17) was so compelling that it struck me as the epitome of Borofsky's autobiographical view—his sense of a fragmented identity so evident today. I guess it is a self-portrait—given the distinctive ears he always puts on his self-portraits—the artist being thrown asunder. It's interesting that the ears are distinctive in Mimmo Paladino's *Mute,* too (cat. 88). Instead of being part of the image printed on the paper, they are made of felt. I acquired the print from the printers, Harlan and

Weaver, who explained that they had to subcontract somebody to make these ears.

RF: There's a strong sense of alienation in many of the prints we've been discussing. In my search for one word that ties them together—that seems to be it.

JS: All of the figures seem to be destroyed in some way—in water, cut off at the knees or at the arms, all the parts are exploded; the most extreme case is Susan Rothenberg's *Stumblebum* (cat. 96), in which the figure is not there—unless you really search for it—the figure is virtually obliterated. In David Salle's prints there are images superimposed on top of other images. If you take the Longo, it's almost like a flat plane; with Bosman's *Drowning Man* (cat. 18), although depth is implied, it's mainly work on the surface; with the Salle, it's not that it's three-dimensional, but we're meant to see images behind other images.

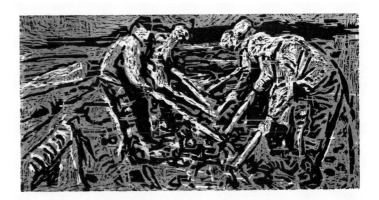

11. Roger Herman, *Fieldwork,* 1984, woodcut on Barrier paper, image: 48¹/₁₆ x 96¹/₁₆ (122 x 244)

RF: The layering becomes a metaphor for the process as well as a form of the image: the complexity of layering—specific readable, measurable layering—in plate after plate, as well as suggesting layers of meaning.

JS: The point is to associate the various images—allow the mind to make the necessary connections, by mentally peeling off layers, undoing what each plate has put down. Another approach to figuration may be seen in Nitsch's

The Last Supper (cat. 87), an obviously somber version of the subject. Nitsch's work suggests an aspect of the European sensibility which has an orientation to the forcefulness of the human body.

RF: As suggested by Yves Klein, for example? But one sees that in American art, too, for example in Rauschenberg's body blueprint of 1949 and Jasper Johns' skin drawings. Jean-Charles Blais' *Untitled* (cat. 14) presents another European artist's approach to the figure.

JS: I got it at the Basel Art Fair in 1986. I was overwhelmed by it—I suppose it's a figure holding onto a tree. Here, too, there are certain unique collage and hand-drawn elements in red in each of the impressions from the edition of twelve. I feel fortunate to have gotten the Blais print in Europe, a work by a major artist not terribly well-known in this country. And Lorenzo Bonechi's *The House of the Angel* (cat. 16) is another example of the same thing—his work was available in Europe long before I ever saw any of it here. I found it to be very, very compelling, and I bought a group of prints the first time I saw them. Another important and also rare European print is the impression of Penck's *Standard West K* (cat. 91), selected from several developmental states of the image. The use of the tool is very apparent in the quality of the line. In this case the tool is used with both delicacy and a certain rawness.

RF: A comparison between *Standard West K* and Penck's woodcut *The Work Continues* (cat. 90) is interesting for the boldness they both have. The woodcut has more of a shape orientation, but both have a similar kind of dramatic play of black and white. Here we are dealing with line that is developed with considerable subtlety, in an additive way, while the woodcut line feels more rapidly and coarsely carved away. It's interesting, too, to consider the more painterly properties of lithography as seen, for example, in Markus Lüpertz' Number II from *Seven About ML* (cat. 74).

JS: Or Franz Hitzler's *Untitled* (cat. 55). I think Hitzler's work in lithography represents an incredible ability to use the special quality of line in as broad a swath as possible in that process, especially in contrast to Hitzler's usual etchings and drypoints. In them, the specificity of line seems more intense. It's one of the things that's so interesting about printmaking—that the distinctive quality of the dif-

ferent techniques adds so much to the image, to the impact of what you see.

RF: Of course, Dennis Kardon's *Pleasure and Power—Second State* (cat. 64) presents a very different view of lithography.

JS: In *Pleasure and Power* and in *Charlotte's Gaze* (cat. 63), he really forces you to examine the surface—seeking a technical equivalent to the subject matter. You feel that you're looking at skin.

RF: There's a translucency.

JS: *Coat* (cat. 50) by Philip Guston is in a different lithography technique entirely. There, as we discussed earlier, is the kind of imagery that has provided a tremendous inspiration for younger artists. When Guston switched from abstraction to representation at the end of his life, the work wasn't especially welcomed by his own generation of artists and critics.

RF: In his work there is a kind of false crudeness, an attempt at projecting a lack of sophistication.

JS: You are talking about what has come to be called "bad painting" (I don't know if there's such a term as "bad printmaking"), in which the artist purposefully introduces an element of clumsiness. I think that enhances the attention one pays to the work, giving it a different kind of meaning than it would have if it were traditionally finely drawn and placed in a coherent context. Expressionistic imagery of artists like Guston, or McNeil, or Joan Snyder in *Mommy Why?* (cat. 103), shows how you can combine a suggestion or veneer of childlike naiveté and the use of visual language, plus the idea that the hand is crucial to the making of the work.

RF: That in part has to do with the authority of the work having to be a crucial part of the meaning of the piece, especially when it is more readily visible, or seen first, before the overall conception of the form. The life of the artists' mark is important in itself. In a more finely tuned work, the mark is usually subsumed within the delineation of the form, and the form is more readily visible, of greater immediate importance, than the mark itself. To bring in another artist, you have a marvelous group of Susan Rothenberg's prints from which we've selected *Stumblebum* and *Pinks* (cats. 96, 95). She is an artist who has worked in lithography, etching, mezzotint, and other

12. Susan Rothenberg, *Boneman*, 1986, mezzotint on wood veneer paper, image: 23¹³/₁₆ x 20³/₁₆ (60.5 x 51.3)

related intaglio processes, and woodcut. *Pinks* is actually a monoprint woodcut.

JS: It seems to me that Rothenberg has mastered several printmaking processes and yet kept the full strength of her identity in each of them; and that's not so easy to do. Often an artist will have a favorite print medium and might have a difficult time making a transition to others. Rothenberg's own expressionistic style, with a certain mystery, seems to work in each medium. She also takes advantage of materials themselves. In the case of the woodcut, especially the monotype woodcut, the grain of the wood is visibly important; in the instance of the mez-

zotint *Boneman* (fig. 12), she's contrasted the medium's softness with the wood veneer paper. She has an uncanny ability to create a strong presence through the physicality of the processes.

RF: Maybe we should shift from the works that are principally figures to those that are primarily places. In the most abstract sense, Steven Sorman's elegant and sensuous mixed media print *The Letter From Matisse* (cat. 105) might be included here.

JS: Yes, and Richard Artschwager's work. His prints tend to be either interiors or landscapes, for example *Mt. St. Helens* (cat. 3). They're extraordinary in achieving a similar kind of strange tonality and detail in print form that he has in his drawings. This one was printed by Paul Marcus who was very enthusiastic about the virtuosity of the artist.

RF: Speaking about virtuosity, we were talking before about Rauschenberg and how his work, represented in the exhibition by *Bellini #1* (cat. 94), holds a very strong and important place in the art of the eighties.

JS: It's as if Rauschenberg is in a second youth, with younger artists involved—as he always has been—with appropriation, with the use of photographic imagery and multiple media, the layering of imagery, mythic references, accepting the possibilities of chance and accident, the large size of images—after all, Rauschenberg pioneered large prints. Plus, there's his effusive spirit.

RF: Another mature figure, William Wiley, is represented in the show by *Eerie Grotto? Okini* (cat. 114), an incredible woodcut published by Crown Point Press and printed in Japan using eighty-five colors.

JS: The use of the woodcut, then, hasn't only been of interest to the emerging artists but to established artists as well. While it certainly happened earlier, increasingly, a lot of artists have been traveling great distances to do prints in particular workshops.

RF: By contrast, Mark Leithauser's incredibly detailed and finely worked *Birches* (cat. 71) is one of the few American prints in the show executed outside of professional, collaborative workshops, more in keeping with many of the European prints.

JS: Among others are those by Mary Frank and George McNeil.

RF: I've always found Jennifer Bartlett's *Shadow* (cat. 5) to be extraordinary in its technical complexity as well as incredibly beautiful in how it conveys the quality of light and a sense of movement in time.

JS: *Shadow* was an enormously complex project, with many different printers involved over a long period of time. Certainly it shows that technical virtuosity and prowess don't have to be sterile. Her art tends to be technically complex —this one is an interesting culmination of her In the Garden series, which includes paintings, drawings, and prints in several media.

RF: And the sense of time passing is an important aspect of the subject of the print. It's interesting as an example of a multi-part image, another feature of many prints of the period, both figurative works and abstractions—for example, Sauro Cardinali's *Annegato* (cat. 22).

JS: Cardinali is an artist I'd never heard of, and wandering through the Basel Art Fair, I saw the work and it fascinated me. It was a difficult transaction because the dealer couldn't speak a word of English and I couldn't speak any Italian.

RF: Among other multi-part pieces in the show, in addition to the Bartlett and the Cardinali, are Michael Mazur's *Wakeby Day*, Ida Applebroog's *Just Watch and See*, and Susan Crile's *Renvers on Two Tracks* (cats. 79, 2, 30). This use of a multiple format is clearly not done for the purposes of making the images big enough, because in many instances single sheets of paper could readily have been located to accommodate them. It has more to do with a statement about expansion or extension, a greater sense of space, of drama.

JS: With the three-part Mazur, there are not only three sheets of paper, there's also the fourth, inset piece. The print could almost be set up as a screen, although I don't think that was in any way his intention. There's a kind of resonance set up by the divisions and an implication of greater scale.

RF: A kind of fragmentation.

JS: Set up by the interruption of the single view, especially in the Mazur and the Bartlett, which I think are related in that sense.

RF: One sees it also in Pat Steir's *The Wave—From the Sea— After Leonardo, Hokusai, & Courbet* (cat. 106), although it consists of multiple images on a single sheet of paper. What we also see in the Steir, another important aspect of the art of the eighties, is that it is art in part about other art. To change the subject, Bruce Nauman is someone in whom you've been interested for some time.

JS: Nauman is another artist to whom younger artists seem to relate in a strong way. The same with Artschwager. And Ed Ruscha.

RF: Ruscha is concerned with issues of verbal/visual language, as evident in *Metro, Petro, Neuro, Psycho* (cat. 97). Of course, Nauman's *House Divided* (cat. 85) represents only one aspect of his art; he also works extensively with visual/ verbal associations.

JS: Right. *House Divided*, though, has relationships with his sculptural ideas. There's a sense of mass created through the insistence of line, and there's that mysterious quality to the form—it's not quite clear how the doorways function.

RF: Another characteristic of the eighties has to do with a clear consciousness, or self-consciousness. While artists may accept accident as part of their process, most artists are extremely in touch with where their art is coming from and where it is going.

JS: That's right, but distinctions may be drawn between the younger artists and the more mature ones. In any event, it seems true that the art of the eighties has reflected this kind of consciousness.

RF: Looking at Jane Dickson's *Yoyo Ride* and Yvonne Jacquette's *Mississippi Night Lights (Minneapolis)* (cats. 34, 60), and I think April Gornik's *Rain and Dust* and Michael Heindorff's *Affirmations IV* (cats. 49, 52)—in all of these works, we're dealing with images that seem to be viewed from a single point, not based on multiple points of view; and it is such an insistent one at that. There's also an incredible softness and sense of atmosphere in all of them. They, in fact, seem to be as much about atmosphere as they are about place, each of them approaching the issue in a very different way, and each of them depending very much on certain possibilities available within the specific print medium employed.

JS: Each artist has picked the medium that fits best within their own work. These carborundum prints were a departure for Jane Dickson, but she since has used the medium a lot. I was fortunate to obtain the working proofs for her Yoyo prints—showing how she evolved her way of working in the medium (*e.g.*, fig. 34a).

RF: The proofs started out with the forms much more tightly contained. She got increasingly atmospheric. It's interesting from the proofs to see how she grew to know how the medium could work.

JS: Jacquette previously had worked in black and white—for example *Aerial View of 33rd Street* (fig. 13)—and *Mississippi Night Lights (Minneapolis)* (cat. 60) was her first major color print. She's sort of printing with light.

RF: It's very different from her black and white prints, which have that kind of glow based on the active role of the translucent Transpagra vellum paper. Here, the bare sheet isn't an active force at all, it's entirely a printed light.

JS: It's interesting—I've never been conscious of trying to buy the work of women artists, but from my earliest collecting I do seem to have done so, and I'm glad to see that you've selected a fair number of women artists for this show. Howardena Pindell is another one. Her *Kyoto: Positive/Negative* (cat. 92) is a wonderful use of several print processes by an artist with great sensitivity to papers and other materials.

RF: To move on, Paul Marcus' woodcuts, *The Auction* and *The Eviction* (fig. 14 and cat. 76) are certainly expansive.

JS: I guess you're referring to their size. Paul Marcus for years worked as a printer for other people but now concentrates on his own work, both prints and paintings.

RF: Yes, the Artschwager and a few other works in the exhibition have been printed by him.

JS: The connection between his work and the social content of prints of the 1930s shows how Paul is a committed social activist and believes that art should reflect one's politics and should be a call to social action.[15]

RF: In the thirties, many prints produced for social reasons employed lithography, which is capable of yielding large numbers of impressions. Marcus is using woodcut, which

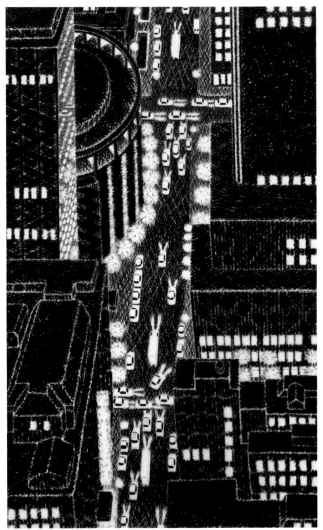

13. Yvonne Jacquette, *Aerial View of 33rd Street*, 1981, lithograph on Transpagra vellum paper, 49¹⁵/₁₆ x 30¹⁵/₁₆ (126.8 x 78.8)

is not capable of producing such large editions, and with the two prints in the show, certainly the size doesn't suggest a large edition either. I suppose he's using the power of the image to communicate the content to a wide audience. Perhaps we should talk briefly about what might be called the biomorphic works, or works that seem to have origins in nature without conveying a specific sense of place. Gregory Amenoff's *In the Fifth Season* (cat. 1) seems to be transitional in that sense, remaining fairly close to nature, but . . .

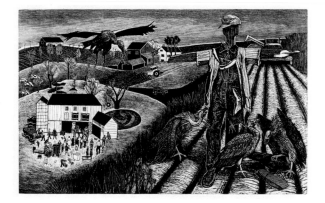

14. Paul Marcus, *The Auction*, 1968, woodcut with drawn additions on Aquaba paper, image: 48¹/₁₆ x 78 (122.1 x 198.2)

JS: Amenoff's work is derived from natural forms as is Melissa Meyers' ''Daphne'' from *Ovid* (cat. 81). Both set up an interesting contrast to the work of Terry Winters or Carroll Dunham, whose forms are more biomorphic. Amenoff seems to come more directly from a representational source, and the work suggests references to trees, for example, although it vacillates between abstracted ambiguity and representation: sometimes there's a clarity to the image elements and sometimes there is not. *In the Fifth Season* is based on one of Amenoff's paintings and is remarkably successful in translating into the woodcut medium the compositional aspects of the painting and the organic abstracted nature of the forms. I believe it is his first woodcut.

RF: I keep coming back to the notion of nature explored and nature exploded—Amenoff's work and Louisa Chase's *Untitled (Water)* (cat. 25) have an affinity in their ties to nature, except the Chase is even more suggestive.

JS: The Chase seems to me to relate to music, the sense of rhythm, a lyrical quality. But it does have both an organic base and a source in a sense of place.

RF: The same might be said of Elizabeth Murray's *Snake Cup* (cat. 84). Her work—in both painting and printmaking— has made an enormous impact during this period. Carroll Dunham has been doing powerful work, too.

JS: I associate Dunham with Terry Winters and John Newman. *Accelerator* (cat. 41) is one of Dunham's first prints, and it

is interesting to see the richness of its tonalities adjacent to the richness of the color in *Full Spectrum* (cat. 42). The color print reminds me of jazz in a way, in its projection of an intensity that's kept under control—intensity reined in. Terry Winters had considerable experience as a painter and draftsman and he was able to translate his talent successfully into making prints. I think that anybody who sees the work *Double Standard* (cat. 115) will not be able to tell immediately that it's not a drawing.

RF: Do you think that's a problem or an asset? I think one point is to search out what is ''printerly'' as distinct from ''draftsmanlike'' in the lithograph. Certainly the physical layer of ink is different from what the physical layer of a charcoal line would be. To move from these biomorphic works, our last group of prints focuses on aspects of a more geometrically oriented abstraction.

JS: Well, Arnulf Rainer (cat. 93) is involved with the abstraction/representation question that has been a key issue in the eighties: the covering over of representation with abstraction, a physical layering. He is a pioneer in exploring this issue. John Newman is very different. He is a sculptor and is involved with certain formulae of physics, although I don't think it's essential to comprehend the theoretical basis in order to experience the interplay of form, tension, and color in a work such as *Two Pulls* (cat. 86).

RF: And there are various relationships between the prints and Newman's sculpture?

JS: Yes, but the prints and drawings exist as independent works. They don't relate to specific pieces of sculpture, but to the kinds of issues he's exploring.

RF: You have a number of Sean Scully's prints, for example, in the exhibition, the large color woodcut *Conversation* (cat. 100). The degree to which Scully's prints imply the actual physical three-dimensional space of his paintings is very impressive.

JS: With Scully, who makes the stripe his subject, the sensuous nature of the printing process, the saturation of color, are very important too.

RF: The structure of Al Held's *Straits of Magellan* (cat. 53) creates a totally different kind of invented spatial environ-

ment—open, fluid, very much in contrast, too, to the density of Howard Hodgkin's *Black Moonlight* and *After Lunch* (cats. 58, 57).

JS: Related to these artists, I suppose, is Oleg Kudryashov, a Russian emigré who lives in London. His work, a unique piece titled *Construction, plate no. 729* (cat. 70) is the only three-dimensional work in the exhibition. He works in drypoint, and he does flat pieces, too, but even with them he only makes one impression of each work.

RF: Troels Wörsel fits here, too.

JS: He's an artist from Denmark, although he's lived in Germany lately. I was attracted by the magic of his sense of abstraction—the quality of his marking.

RF: There's a strong sense of speed in the work.

JS: Again it calls to mind jazz in the sense of being energy that somebody is really putting out, with passion and with power, yet it's under control. There's a sense of intensity and rhythm, but knowing that the person who's done this work has a masterful control over all of its elements.

RF: I suppose on some level masterful control is what all of the work is about. Perhaps it is what forming a collection is about as well. You have certainly done a wonderful job on that score, touching upon virtually every current that has activated the world of prints during the extraordinary decade that is about to come to an end. It has been wonderful for me to watch your collection take shape; and all of us here at the National Gallery are delighted that we are able to share your collection of prints of the 1980s with our visitors.

Notes:

1. On several Washington collectors including Mr. Smith, see Iris Krasnow, "Profiles in Passion," *Museum & Arts Washington* 3 (September/October 1987), 44–49.
2. This interview assumes a basic knowledge of printmaking techniques on the part of the reader. For more information, see Donald Saff and Deli Sacilotto, *Printmaking: History and Process* (New York, 1978).
3. *Awards in the Visual Arts 1* [exh. cat., Southeastern Center for Contemporary Art, with the National Museum of American Art] (Winston-Salem, N.C. and Washington, D.C., 1982), with an essay by Harry Rand.
4. See *Mülheimer Freiheit Group* [exh. cat., Milwaukee Art Museum] (Milwaukee, 1987), with an essay by Dean Sobel.
5. See *The Painterly Print: Monotypes from the Seventeenth to the Twentieth Century* [exh. cat., The Metropolitan Museum of Art] (New York, 1980), with essays by Sue Welsh Reed, Eugenia Parry Janis, Barbara Stern Shapiro, David W. Kiehl, Colta Ives, and Michael Mazur.
6. For example, see *Drawings: The Pluralist Decade* [exh. cat., Institute of Contemporary Art, University of Pennsylvania] (Philadelphia, 1980), with essays by Janet Kardon, John Hallmark Neff, Rosalind Krauss, Richard Lorber, Edit deAk, John Perreault, and Howard N. Fox.
7. Many other printers and publishers are cited in the entries throughout this catalogue.
8. See Joshua P. Smith, *The Photography of Invention: American Pictures of the 1980s* [exh. cat., National Museum of American Art] (Washington, D.C. and Cambridge, MA, 1989), with an introduction by Merry Foresta.
9. Photographer William Henry Fox Talbot (1800–1877) is the source for the term "Pencil of Nature," the title of his publication of twenty-four prints, mainly calotypes, issued between 1844 and 1846 in six fascicles.
10. For technical information, see Deli Sacilotto, *Photographic Printmaking Techniques* (New York, 1982).
11. Elke Solomon, *Oversize Prints* [exh. cat., Whitney Museum of American Art] (New York, 1971).
12. Jürgen Partenheimer to Joshua Smith, 24 January 1985.
13. On Tamarind see *Tamarind: 25 Years* [exh. cat., University Art Museum, University of New Mexico] (Albuquerque, 1985), with an essay by Carter Ratcliff.
14. Ruth E. Fine and William Matheson, *Printers' Choice: A Selection of American Press Books, 1968–1978* [exh. cat., The Grolier Club, 1978] (Austin, 1983).
15. See Deborah Wye, *Committed to Print* [exh. cat., The Museum of Modern Art] (New York, 1988).

* All illustrations are from works in Mr. Smith's collection.

Catalogue of the Exhibition

Gregory Amenoff

Ida Applebroog

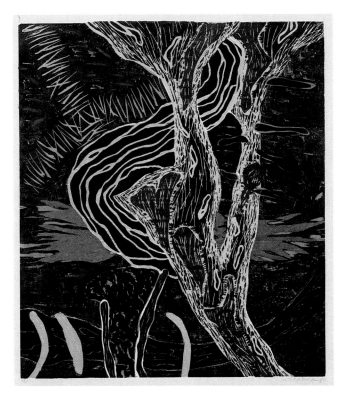

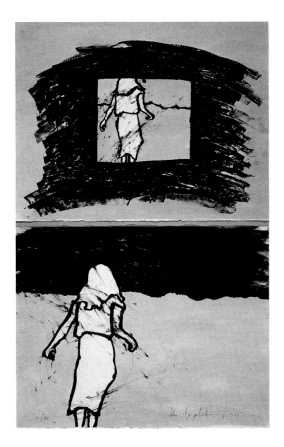

1. **In the Fifth Season**, 1983
Woodcut on Sekishu paper
Image: 36¹/₄ x 32 (92.0 x 81.3)
Sheet: 41¹/₂ x 36⁷/₈ (105.5 x 93.8)
Edition: 25, plus 13 proofs
Printed by Chip Elwell, New York
Published by Diane Villani Editions, New York

2. **Just Watch and See**, 1985
Lithograph with painted additions on two sheets of Arches paper
Image and sheet: 22¹/₄ x 29⁵/₁₆ (56.5 x 74.4), each sheet
Edition: 40, plus 24 proofs
Printed by John Nichols Printmakers & Publishers, New York, assisted
 by Arnold Brooks and in collaboration with the artist
Published by Strother/Elwood Art Editions, Brooklyn

Richard Artschwager

Donald Baechler

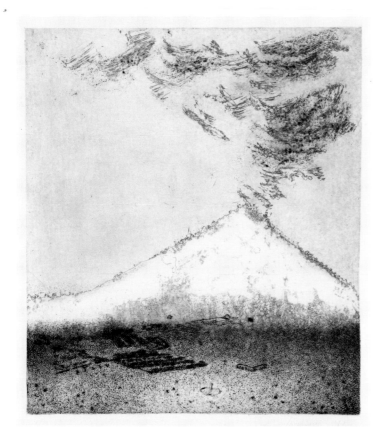

4a

3. **Mt. St. Helens**, 1981
Etching and drypoint on Velin Arches paper
Image: 17⁹/₁₆ x 15³/₄ (44.6 x 40.0)
Sheet: 27¹¹/₁₆ x 24⁷/₈ (70.2 x 63.0)
Edition: 20, plus 9 proofs
Printed by Paul Marcus, with processing by Patricia Branstead,
 Aeropress, New York
Published by Multiples, Inc., New York

4a, b. Two "Untitled" prints from **Family**, 1986
A portfolio of four etchings and aquatints on 105 g. Arches paper
Image: 13¹/₄ x 9⁹/₁₆ (33.7 x 24.6)
Sheet: 21³/₁₆ x 15 (53.8 x 38.1)
Edition: 12, plus 3 proofs
Printed by Kurt Zein, Radierwerkstatt, Vienna
Published by Galerie Krinzinger, Vienna

Jennifer Bartlett

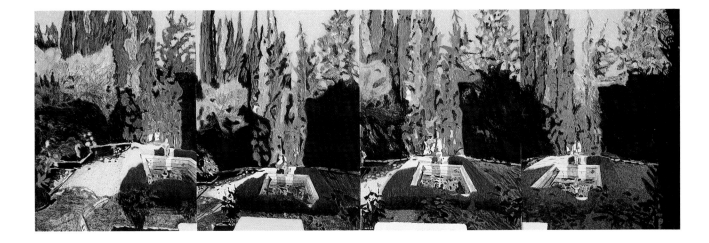

5. **Shadow**, 1984
Softground etching, aquatint, spitbite, drypoint, and burnishing on
 four sheets of Fabriano Tiepolo paper
Image and sheet: 29^{13}/$_{16}$ x 22^{5}/$_{16}$ (75.6 x 56.6), each sheet
Edition: 60, plus 17 proofs
Printed by Simon Draper, Felix Harlan, Yong Soon Min, Catherine
 Tirr, and Carol Weaver, with processing by Patricia Branstead,
 Aeropress, New York
Co-published by Paula Cooper Gallery and Multiples, Inc., New York

Georg Baselitz

6. Landschaft (Landscape), 1980
Linocut on antique wove paper
Image: 15 1/8 x 9 5/8 (38.5 x 24.5)
Sheet: 24 1/8 x 17 1/16 (61.2 x 43.3)
Edition: unique first state
Printed and published by the artist, Derneburg

7. Landschaft (Landscape), 1980
Linocut on antique wove paper
Image: 15 5/16 x 9 5/8 (39.0 x 24.5), irregular
Sheet: 24 1/8 x 17 1/16 (61.3 x 43.3)
Edition: unique third state
Printed and published by the artist, Derneburg

Georg Baselitz

8. **Landschaft (Landscape)**, 1980
Linocut on antique wove paper
Image: 15¼ x 9⁷/₁₆ (38.8 x 24.0), irregular
Sheet: 24⅛ x 17¹/₁₆ (61.3 x 43.3)
Edition: unique
Printed and published by the artist, Derneburg

9. **Landschaft (Landscape)**, 1980
Linocut on antique wove paper
Image: 15⅛ x 9⁷/₁₆ (38.4 x 24.0), irregular
Sheet: 24¹/₁₆ x 17 (61.1 x 43.2)
Edition: unique first state
Printed and published by the artist, Derneburg

Georg Baselitz

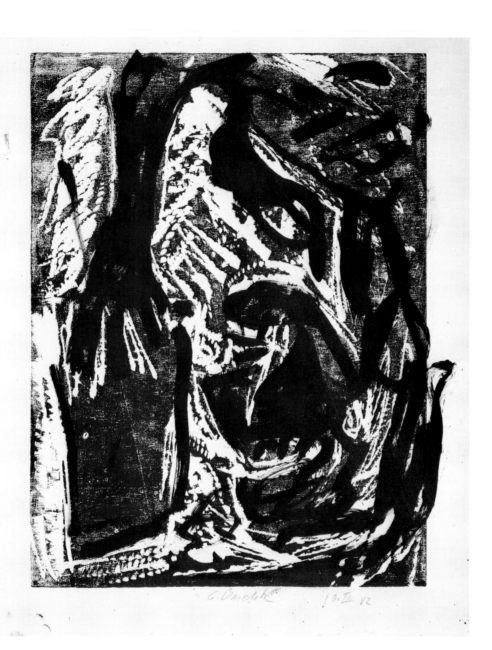

10. **Lesender Mann** (**Reading Man**), 1982
Woodcut with painted additions on offset paper
Image: 25 9/16 x 21 1/16 (65.0 x 53.5), irregular
Sheet: 33 13/16 x 24 1/16 (85.8 x 61.1)
Edition: unique proof of first state
Printed by the artist, Derneburg
Published by Maximilian Verlag-Sabine Knust, Munich

Mark Beard

11. **Neo-Classik Comix**, 1985
Monoprint drypoint with drawn additions and pen calligraphy on
 J. B. Green's handmade Crisbrook paper
Sheet: 5^1/$_{16}$ x 13^{13}/$_{16}$ (12.9 x 35.1), irregular
Book: 5^5/$_{16}$ x 14 (13.5 x 35.6)
Edition: 18 (numbered 1–11; A–G)
Printed by the artist, assisted by Sebastian Li and Georg Osterman,
 Bob Blackburn's Printmaking Workshop, New York
Letterpress set by Marc Shifflett and printed at Wild Carrot
 Letterpress, Hadley, Massachusetts; endpapers by Sebastian Li;
 bound by Gérard Charrière.
Published by Vincent Fitz Gerald & Company, New York

Jake Berthot

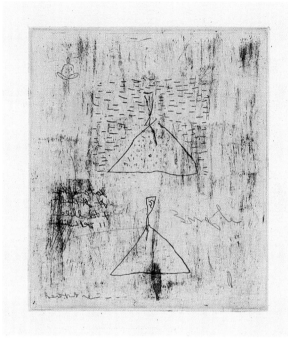

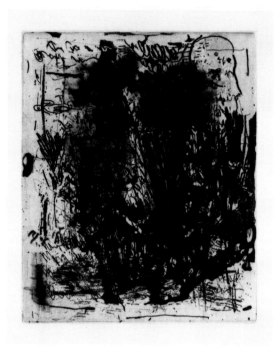

12. "Untitled" from **Portfolio I**, 1983
A portfolio of eight etchings and aquatints, this one with chine collé
 of Kitakata paper on heavyweight Rives paper
Image: 4⁷/₁₆ x 3¹⁵/₁₆ (11.3 x 9.9)
Sheet: 13¹/₈ x 10 (33.3 x 25.4)
Edition: 16, plus 3 proofs
Printed by Paul Marcus, Pycus Studio, New York
Published by the artist, New York

13. "Untitled" from **Portfolio II**, 1983
A portfolio of eight etchings and aquatints on heavyweight Rives
 paper
Image: 4¹⁵/₁₆ x 4¹/₁₆ (12.6 x 10.3)
Sheet: 13¹/₈ x 10 (33.3 x 25.4)
Edition: 16, plus 3 proofs
Printed by Paul Marcus, Pycus Studio, New York
Published by the artist, New York

Jean-Charles Blais

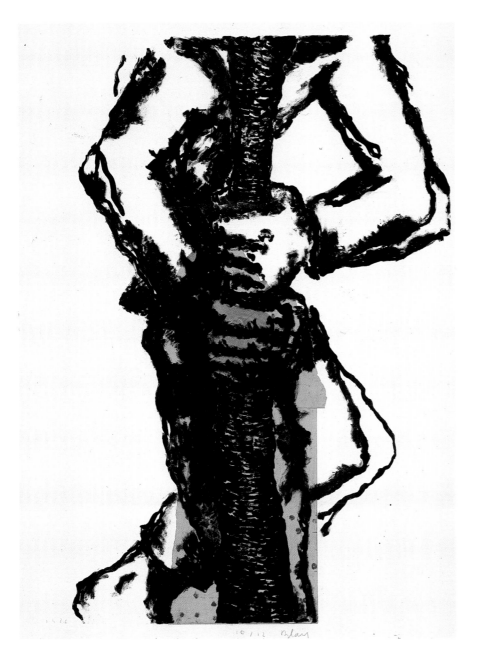

14. **Untitled**, 1986
Lithograph with collage and painted additions on 400 g. Velin
 Arches paper
Image and sheet: 63³⁄₈ x 47¹⁄₈ (161.0 x 119.5)
Edition: 12 unique variants
Printed by Atelier Franck Bordas, Paris
Co-published by the artist and Atelier Franck Bordas, Paris

Mel Bochner

Lorenzo Bonechi

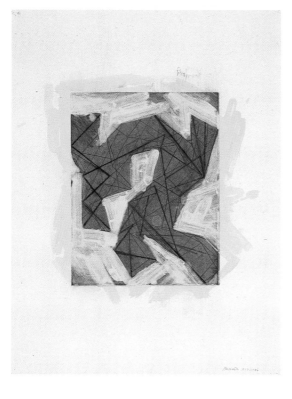

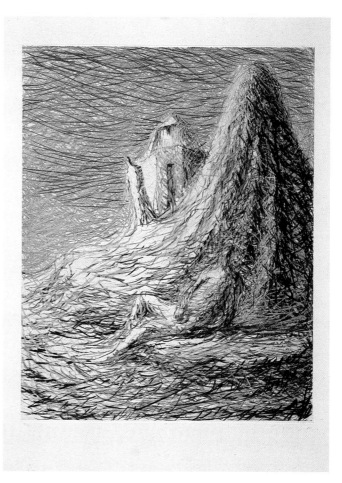

15. Untitled (Burnt Yellow), 1982–1986
Etching and drypoint with painted additions and chine collé of
 orange tissue on wove paper
Image: 14⅞ x 11¾ (37.8 x 29.8), irregular
Sheet: 28⅝ x 22 (72.7 x 55.9)
Edition: unique
Printed by Jeryl Parker Editions, New York
Published by the artist

16. La Casa dell'Angelo (The House of the Angel), 1984
Softground etching on Arches paper
Image: 24 x 19¼ (61.0 x 49.9)
Sheet: 30 x 22¼ (76.2 x 48.0)
Edition: 50, plus 8 proofs
Printed by Stamperia Carini, San Giovanni Valdarno
Published by Carini Editori, Florence

Jonathan Borofsky

17. **Stick Man**, 1983
Lithograph on Arches 88 paper
Image and sheet: 52⁷/₁₆ x 37³/₄ (133.3 x 95.9)
Edition: 27, plus 21 proofs
Printed by Anthony Zepeda and James Reid, Gemini G.E.L.
Published by Gemini G.E.L., Los Angeles

Richard Bosman

18. **Drowning Man**, 1981
Woodcut on Okawara paper
Image: 40 1/8 x 24 (101.9 x 61.0)
Sheet: 47 5/8 x 30 (121.0 x 76.2)
Edition: 47, plus 15 proofs
Printed by Chip Elwell and Ted Warner, New York
Published by Brooke Alexander, Inc., New York

19. **Polar Bear**, 1981
Woodcut on Oriental DPA-2 paper
Image: 23 7/8 x 22 (60.8 x 55.9)
Sheet: 30 1/8 x 25 1/2 (76.5 x 64.8)
Edition: 14, in two versions, plus 4 proofs
Printed by the artist, Brooke Alexander, Chip Elwell and Ted Warner,
 New York .
Published by Brooke Alexander, Inc., New York
National Gallery of Art, Washington, Gift of Joshua P. Smith,
 1986.84.1

Chris Burden

THE ATOMIC ALPHABET

A for ATOMIC　　　　原子

B for BOMB　　　　　爆弾

C for COMBAT　　　　戦闘

D for DUMB　　　　　馬鹿

E for ENERGY　　　　原動力

F for FALLOUT　　　　原子灰

G for GUERRILLA　　　奇襲隊

H for HOLOCAUST　　大焼尽

I for IGNITE　　　　　発火

J for JUNGLE　　　　密林地帯

K for KILL　　　　　　殺害

L for LIFE　　　　　　生命

M for MUTANT　　　　突然変異体

N for NUCLEAR　　　原子核

O for OBLITERATE　　抹殺

P for PANIC　　　　　恐慌

Q for QUAKE　　　　地震

R for RUBBLE　　　　粉砕

S for STRIKE　　　　奇襲

T for TARGET　　　　標的

U for URANIUM　　　重金属元素

V for VICTORY　　　　勝利

W for WAR　　　　　戦争

X for RAY　　　　　　照射線

Y for YELLER　　　　腰抜け

Z for ZERO　　　　　零

20. **The Atomic Alphabet**, 1980
Photo and softground etching with painted additions on Arches 88
　　paper
Japanese calligraphy by Hidekatsu Takada
Image: 53³/₄ x 35⁵/₈ (136.5 x 90.5)
Sheet: 57⁵/₈ x 39³/₄ (146.2 x 101.0)
Edition: 20, plus 11 proofs
Printed by Hidekatsu Takada, assisted by Peter Pettengill, Crown
　　Point Press
Published by Crown Point Press, Oakland, California

Steven Campbell

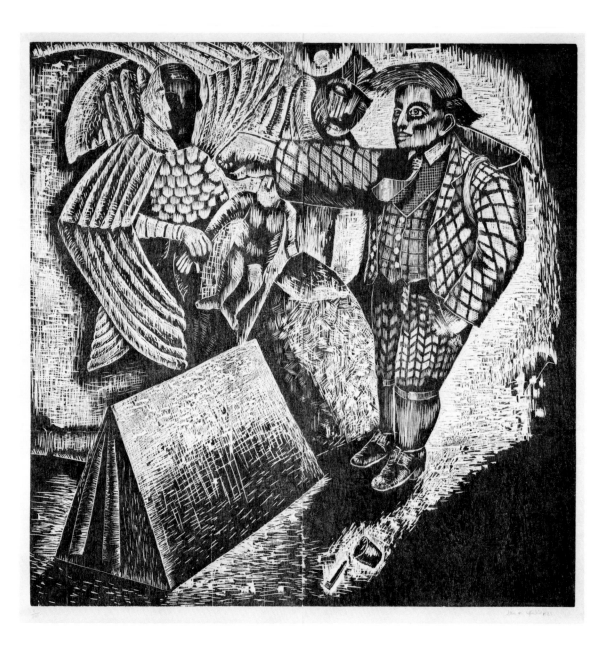

21. **The Hiker Said, ''Death You Shall Not Take the Child,''** 1983
Woodcut in two panels on six sheets of Sekishu paper
Left image: 95⁷/₈ x 48¹/₁₆ (243.5 x 122.1)
Left panel: 100⁷/₈ x 50¹/₁₆ (256.2 x 127.2)
Right image: 96 x 48 (244.0 x 122.0)
Right panel: 101 x 50¹/₁₆ (256.6 x 127.2)
Edition 15, plus 5 proofs
Printed by Chip Elwell and Steven Rodriguez, New York
Published by Barbara Toll Fine Arts, New York

Sauro Cardinali

22. **Annegato** (**Person Drowning**), 1985
Resin relief on two sheets of Fabriano paper
Left image: 37^1/$_2$ x 26^1/$_4$ (95.3 x 66.7)
Left sheet: 39^1/$_8$ x 27^9/$_{16}$ (99.4 x 70.0)
Right image: 37^{15}/$_{16}$ x 26^3/$_8$ (96.4 x 67.0)
Right sheet: 39^1/$_8$ x 27^5/$_8$ (99.4 x 70.1)
Edition: 3
Printed and published by the artist

Vija Celmins

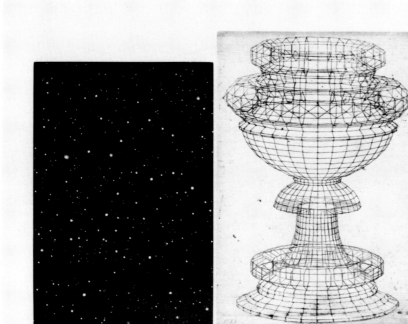

23. **Constellation—Uccello**, 1983
Aquatint and etching on Fabriano Rosaspina paper
Image: 9¹³/₁₆ x 13¹/₁₆ (24.9 x 33.2), irregular
Sheet: 27³/₈ x 23¹/₈ (69.5 x 58.7)
Edition: 49, plus 20 proofs
Printed by Doris Simmelink and Ken Farley, Gemini G.E.L.
Published by Gemini G.E.L., Los Angeles

Vija Celmins

24. **The View**, 1985
Written by Czeslaw Milosz
Four mezzotints on Rives BFK paper
Sheet: 14⁷/₈ x 10⁷/₈ (37.8 x 27.7)
Book: 15¹/₈ x 11³/₈ (38.4 x 28.8)
Edition: 120
Printed by Doris Simmelink, Los Angeles
Designed by Eleanor Caponigro; letterpress printed by
 Meriden-Stinehour Press, Lunenburg, Vermont, on Twinrocker
 paper made by Kathryn Clark and Chris Gipson; bound by
 George Wieck at Moroquain, Inc., Hopewell Junction, New York
Published by the Library Fellows of the Whitney Museum of
 American Art, New York

Louisa Chase

Sandro Chia

25. **Untitled (Water)**, 1984
Drypoint, aquatint, spitbite, and softground on Velin Arches paper
Image: 25 1/2 x 23 7/8 (64.7 x 60.6)
Sheet: 33 5/8 x 28 (85.4 x 71.1)
Edition: 30, plus 18 proofs
Printed by Sally Mara Sturman and Jane Kent, with processing by
 Felix Harlan and Carol Weaver, Harlan & Weaver Intaglio,
 New York
Published by Diane Villani Editions, New York

26. **Fish Bearer**, 1983
Etching and saltlift, with chine collé of Kitakata on Somerset paper
Image: 11 13/16 x 8 3/4 (30 x 22.4)
Sheet: 29 3/4 x 22 13/16 (75.7 x 58)
Edition: 25, plus 6 proofs
Printed by Felix Harlan and Carol Weaver, Harlan & Weaver Intaglio,
 New York
Published by Galerie Bruno Bischofberger, Zürich

Francesco Clemente

27. **I**, 1982
Woodcut on Kozo paper
Image: 14³/₁₆ x 20¹/₁₆ (35.9 x 51.0)
Sheet: 16³/₄ x 22¹/₂ (42.6 x 57.1)
Edition: 100, plus 16 proofs
Printed by Tadashi Toda, Shi-un-do Print Shop, Kyoto, Japan
Published by Crown Point Press, Oakland, California

28. **Untitled**, 1984
Woodcut on Tosa Kozo paper
Image: 14³/₁₆ x 21⁵/₁₆ (36.0 x 51.1)
Sheet: 16¹³/₁₆ x 22¹/₂ (42.7 x 57.2)
Edition: 200, plus 27 proofs
Printed by Tadashi Toda, Shi-un-do Print Shop, Kyoto, Japan, with
 coordination by Hidekatsu Takada
Published by Crown Point Press, Oakland, California

Gregory Crane

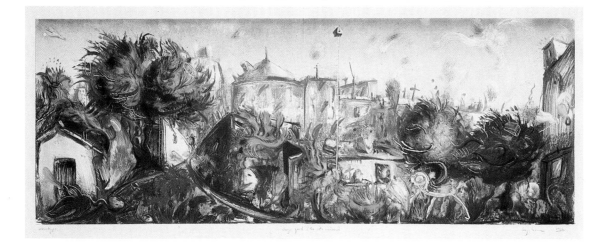

29. **Greg's Yard (The Little Houses)**, 1986
Monotype on Rives BFK paper
Image: 11¹¹/₁₆ x 31⁷/₁₆ (29.6 x 79.8)
Sheet: 23⁹/₁₆ x 42³/₄ (59.6 x 108.6)
Edition: unique
Printed by Cheryl Pelavin, Pelavin Editions
Published by Pelavin Editions, New York

Susan Crile

Enzo Cucchi

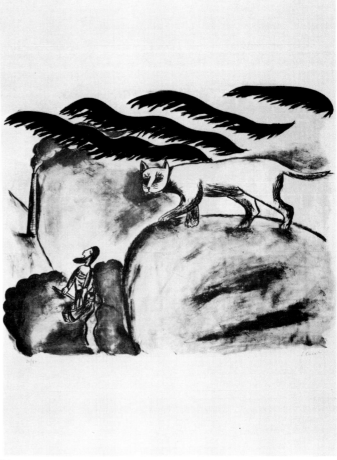

31a

30. **Renvers on Two Tracks**, 1982
Woodcut on two sheets of Gampi Torinoko paper
Left image and sheet: 24 x 18⅛ (60.9 x 46.0)
Right image and sheet: 23¹⁵/₁₆ x 18 (60.8 x 46.3)
Edition: 35, plus 6 proofs
Printed by Chip Elwell, New York
Published by 724 Prints, Inc., New York

31a., b. "Al buio sul mare Adriatico" ("On the Adriatic Sea at
 Night") and "Il Santo di Loreto" ("The Saint of Loreto") from
 Immagine Feroce (Fierce Image), 1981
A portfolio of five lithographs on Fabriano Rosaspina paper
Image and sheet: 25 x 18¹¹/₁₆ (63.5 x 47.5)
Edition: 50, plus 6 proofs
Printed by Eleonora and Valter Rossi, Vigna Antoniniana Stamperia
 d'Arte, Rome
Published by Peter Blum Edition, New York

Walter Dahn

Martha Diamond

32. **Kleine Kreuzigung mit Tee (Small Crucifixion with Tea)**,
 1985
Screenprint on packing paper
Image: 30⅛ x 21 (76.5 x 53.3), irregular
Sheet: 35⁹/₁₆ x 25⅞ (90.3 x 65.7)
Edition: 7
Printed by the artist, Cologne
Published by Galerie Six Friedrich, Munich

33. **Windows**, 1981
Monotype on Rives BFK paper
Image and sheet: 40¹/₁₆ x 26¹/₁₆ (101.8 x 66.2)
Edition: unique
Printed and published by the artist, New York

Jane Dickson

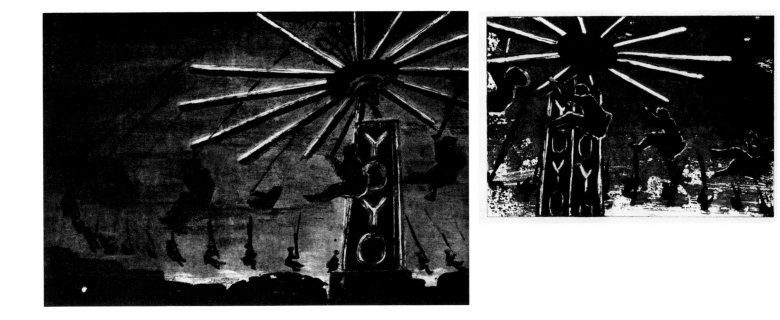

34. **Yoyo Ride**, 1986
Carborundum etching on German Etching paper
Image and sheet: 29 1/2 x 43 5/8 (75.0 x 111.0)
Edition: 30
Printed by Maurice Payne, New York
Published by Joe Fawbush Editions, New York

34a. **Yoyo Ride** (unique trial proof), 1986
Carborundum etching on wove paper
Image: 12 x 17 3/4 (30.5 x 45.2)

Richard Diebenkorn

35. **Black Club**, 1981
Etching and aquatint on Arches Satine paper
Image: 13 1/2 x 9 7/16 (34.2 x 24.0)
Sheet: 30 5/16 x 22 5/8 (77.0 x 57.6)
Edition: 35, plus 22 proofs
Printed by Nancy Anello, assisted by Lilah Toland and Hidekatsu
 Takada, Crown Point Press
Published by Crown Point Press, Oakland, California

Richard Diebenkorn

36. **Combination**, 1981
Spitbite etching and aquatint on Arches Satine paper
Plate: 15⁹/₁₆ x 13¹/₂ (39.6 x 34.3)
Sheet: 30⁷/₈ x 24¹/₂ (78.5 x 62.1)
Edition: 40, plus 15 proofs
Printed by Nancy Anello, assisted by Lilah Toland and Hidekatsu
　　Takada, Crown Point Press
Published by Crown Point Press, Oakland, California

Jiri Georg Dokoupil

Felix Droese

37a

37 a,b. Two "Untitled" prints from **Dokoupil**, 1986
A portfolio of nine screenprints with painted additions on Rives BFK
 paper
Image and sheet: 22³/8 x 22⁹/16 (56.9 x 57.3)
Edition: 33, plus 6 proofs
Printed by Bert Berens, Seri-Grafic, Cologne
Published by Delano Greenidge Editions, New York

38. **Glockenschiff (Bell Ship)**, 1981
Monoprint woodcut on white tissue paper
Image: 9¹/2 x 7 (24.0 x 18.0)
Sheet: 13⁷/8 x 10¹/8 (35.2 x 25.7)
Edition: unique
Printed and published by the artist, Düsseldorf

Felix Droese

39. **Glockenschiff** (**Bell Ship**), 1981
Monoprint woodcut on brown wrapping paper
Image: 9⁷/₁₆ x 7¹/₈ (24.0 x 18.1)
Sheet: 18¹/₂ x 12³/₄ (47 x 33.5)
Edition: unique
Printed and published by the artist, Düsseldorf

40. **Glockenschiff** (**Bell Ship**), 1982
Monoprint woodcut on salmon-colored tissue paper
Image and sheet: 11¹¹/₁₆ x 8¹/₈ (29.7 x 20.8)
Edition: unique
Printed and published by the artist, Düsseldorf

Carroll Dunham

41. **Accelerator**, 1985
Lithograph on Rives BFK paper
Image and sheet: 41⁷/₈ x 29³/₄ (106.4 x 75.6)
Edition: 51, plus 9 proofs
Printed by Keith Brintzenhofe, Universal Limited Art Editions, Inc.
Published by Universal Limited Art Editions, Inc., West Islip, New York

Carroll Dunham

42. **Full Spectrum**, 1985–1987
Lithograph on J. Whatman 1951 paper
Image and sheet: 41⅝ x 27⅞ (105.7 x 70.8)
Edition: 68, plus 18 proofs
Printed by Keith Brintzenhofe, Douglas Volle and Craig Zammiello,
 Universal Limited Art Editions, Inc.
Published by Universal Limited Art Editions, Inc., West Islip, New York

Aaron Fink

43. Blue Smoker, 1982
Lithograph on blue Kozo paper
Image and sheet: 38¼ x 25⅜ (97.2 x 64.4)
Edition: 50, plus 18 proofs
Printed by Herb Fox, Fox Graphics, Ltd., Boston
Published by the artist, Boston

44. ''The Self-Made Man and the Moon'' from **Perhaps**, 1985
A portfolio of seven etchings, with text by Paul Genega, on Arches
 paper
Image and sheet: 23¹¹/₁₆ x 17¹¹/₁₆ (60.2 x 44.9)
Edition: 35
Printed by James Stroud, Center Street Studio, Gloucester,
 Massachusetts
Letterpress set by Dan Carr and Julia Ferrarie and printed by Bruce
 Chandler, Ardeaurum Workshop, Boston
Published by the artist, Boston

Eric Fischl

45. **Year of the Drowned Dog**, 1983
Etching, aquatint, softground, drypoint and scraping on 6 sheets of
 Zerkall paper
Images and sheets:
a. 22^1/$_2$ x 34^{11}/$_{16}$ (57.0 x 88.1)
b. 21^5/$_8$ x 16^3/$_4$ (54.9 x 42.5)
c. 23^1/$_8$ x 19^1/$_2$ (58.9 x 49.5)
d. 17^1/$_2$ x 11^1/$_8$ (44.5 x 28.3)
e. 12^9/$_{16}$ x 9^9/$_{16}$ (31.9 x 24.6)
f. 22^3/$_8$ x 11^3/$_8$ (56.9 x 28.9)
Edition: 35, plus 10 Roman numeraled copies
Printed by Peter Kneubühler, Zürich
Published by Peter Blum Edition, New York

Eric Fischl

Mary Frank

46. **Annie, Gwen, Lilly, Pam and Tulip**, 1986
Written by Jamaica Kincaid
Nine lithographs on Rives BFK paper
Sheet: 20⅛ x 15 (51.1 x 38.1)
Book: 20⁵/₁₆ x 15³/₁₆ (51.6 x 38.6)
Edition: 145, plus several proofs
Printed by John Hutcheson and Kate Notman, Palisades Press, Jersey
 City, New Jersey
Designed by Eleanor Caponigro; letterpress set and printed by
 Michael and Winifred Bixler, Skaneateles, New York; bound by
 George and Catherine Wieck, Moroquain, Inc., Hopewell
 Junction, New York
Published by the Library Fellows of the Whitney Museum of
 American Art, New York

47. **Untitled (Woman)**, 1979–1980
Monotype on wove paper
Image: 35⁷/₁₆ x 23³/₈ (90.0 x 59.4), irregular
Sheet: 37⁵/₈ x 24³/₄ (95.6 x 62.8)
Edition: unique
Printed and published by the artist, New York

Glenn Goldberg

April Gornik

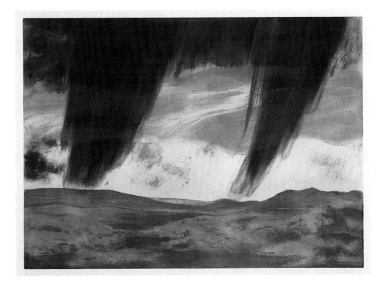

48. **Coil Print**, 1986
Etching, drypoint, and aquatint on Rives BFK paper
Image: 17¹³/₁₆ x 13⁷/₈ (45.3 x 35.2)
Sheet: 30 x 22⁷/₁₆ (76.2 x 57.0)
Edition: 35, plus 3 proofs
Printed by Sally Mara Sturman, New York
Published by Editions Ilene Kurtz, New York

49. **Rain and Dust**, 1985
Etching, aquatint, and spitbite on German Etching paper
Image: 24³/₄ x 34⁵/₈ (63.0 x 87.9)
Sheet: 31¹/₁₆ x 42⁷/₁₆ (79.1 x 107.8)
Edition: 80, plus 15 proofs
Printed by Sylvia Roth, assisted by Susan Mallozzi, Hudson River
 Editions, Garnerville, New York
Published by the Jane Voorhees Zimmerli Art Museum, Rutgers
 University, New Brunswick, New Jersey

Philip Guston

Michael Hafftka

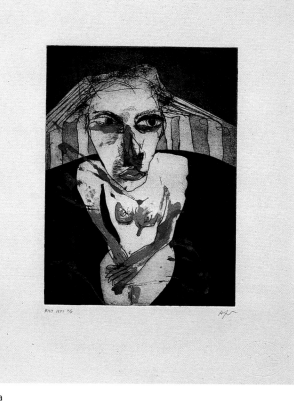

51a

50. **Coat**, 1980
Lithograph on Velin Arches paper
Image and sheet: 32 x 42⅝ (81.3 x 108.3)
Edition: 50, plus 18 proofs
Printed by Christine Fox and Martin Klein, Gemini G.E.L.
Published by Gemini G.E.L., Los Angeles

51a, b. Two "Untitled" prints from **Overtones**, 1985
A portfolio of four etchings and lift ground aquatints on Fabriano
 Tiepolo paper
Image: 11¹³/₁₆ x 8 ¹⁵/₁₆ (30.0 x 22.7)
Sheet: 18³/₈ x 14⁷/₈ (46.7 x 37.8)
Edition: 6, plus 2 proofs
Printed by the artist, with processing by Mark Baron
Published by Mark Baron, New York

Michael Heindorff

Al Held

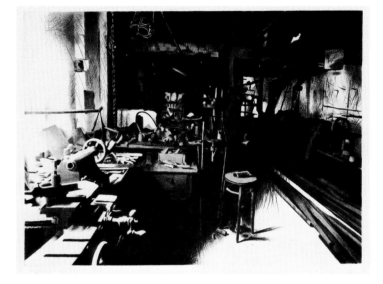

52. **Affirmations IV**, 1980
Drypoint on R. K. Burt paper
Image: 18 1/4 x 25 3/8 (46.4 x 64.4)
Sheet: 27 1/2 x 37 3/4 (69.8 x 95.8)
Edition: 30, plus 6 proofs
Printed by Richard Michell, Birgit Skiold Workshop
Published by Bernard Jacobson Ltd., London

53. **Straits of Magellan**, 1986
Etching on Arches paper
Image: 35 3/4 x 44 5/8 (90.8 x 113.3)
Sheet: 41 3/4 x 51 1/2 (106.0 x 130.9)
Edition: 50, plus 28 proofs
Printed by Renée Bott, assisted by Lawrence Hamlin and Nancy
 Anello, Crown Point Press
Published by Crown Point Press, San Francisco, California

Roger Herman

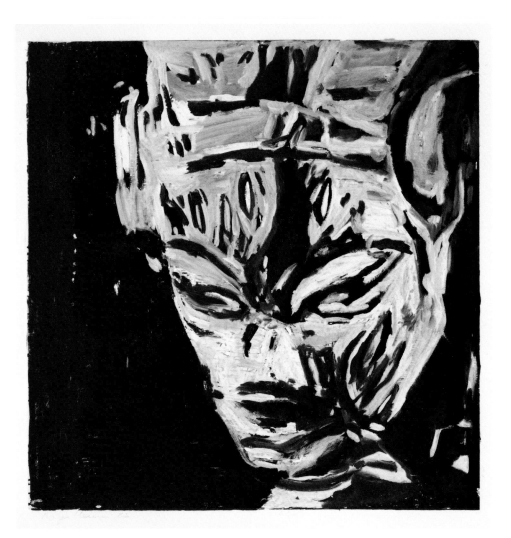

54. **Mask**, 1985
Woodcut with painted additions on Barrier paper
Image: 48 1/2 x 48 (122.2 x 121.9)
Sheet: 72 5/8 x 60 (184.5 x 152.5)
Edition: unique
Printed and published by the artist, Los Angeles

Franz Hitzler

Antonius Höckelmann

55. **Untitled**, 1982
Lithograph on Rives BFK paper
Image: 38 x 25¹/₂ (96.5 x 64.8)
Sheet: 39¹/₂ x 27⁵/₈ (100.3 x 70.2)
Edition: 20, plus a few proofs
Printed by Karl Imhof, Munich
Published by Galerie Fred Jahn, Munich

56. **Head**, 1978–1983
Drypoint on German Etching paper
Image: 20⁷/₁₆ x 15⁷/₈ (51.9 x 40.3)
Sheet: 28¹/₄ x 21¹/₁₆ (71.8 x 53.5)
Edition: 9, plus a few proofs
Printed by Karl Imhof, Munich
Published by Galerie Fred Jahn, Munich

Howard Hodgkin

57. **After Lunch**, 1980
Softground etching and aquatint with painted additions on Velin
 Arches paper
Image and sheet: 22⁵/₁₆ x 30¹/₁₆ (56.8 x 76.3)
Edition: 100, plus 20 proofs
Printed and hand-colored by Ken Farley, Petersburg Press, Inc.
Published by Petersburg Press, Inc., New York and London

58. **Black Moonlight**, 1980
Lithograph with painted additions on two sheets of Rives BFK paper
Left image and sheet: 44¹/₈ x 25¹/₄ (120.0 x 64.0)
Right image and sheet: 44¹/₈ x 30 (111.2 x 76.5)
Edition: 50, plus 25 proofs
Printed by Judith Solodkin and hand-colored by Cinda Sparling at
 Solo Press, New York
Published by Bernard Jacobson, Ltd., London and New York
National Gallery of Art, Washington, Gift of Joshua P. Smith,
 1985.76.5 and 1985.76.6

Jörg Immendorff

59. **folgen** (**consequences**), 1983
Linocut with painted additions from Café Deutschland, on offset
 paper
Image: 62¹/₂ x 81⁵/₈ (158.7 x 207.4), irregular
Sheet: 70⁷/₈ x 90⁹/₁₆ (180.0 x 230.0)
Edition: 10, plus 3 proofs
Printed by the artist, Düsseldorf
Published by Maximilian Verlag-Sabine Knust, Munich

Yvonne Jacquette

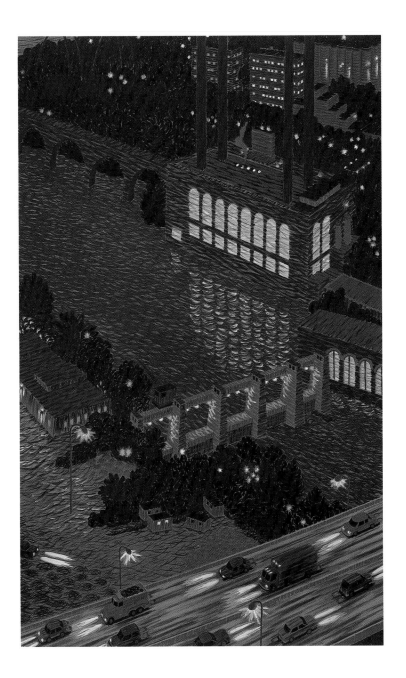

60. **Mississippi Night Lights (Minneapolis)**, 1985–1986
Lithograph and screenprint on 350g. Velin Arches paper
Image and sheet: 58$\frac{1}{2}$ x 36$\frac{1}{8}$ (147.6 x 91.8)
Edition: 60, plus 23 proofs
Printed by Maurice Sanchez, James Miller and Michelle French,
 Derrière L'Etoile Studios, New York
Published by Brooke Alexander, Inc., New York

Bill Jensen

Jasper Johns

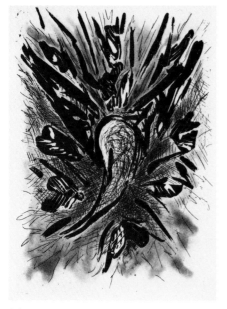

61b

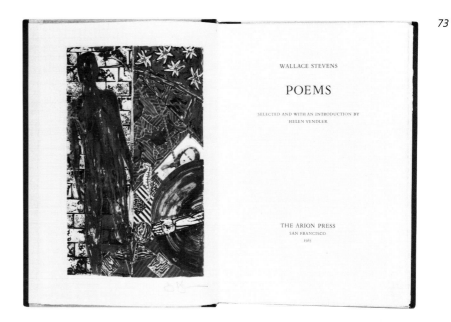

61a., b. ''Fearless'' and ''Mussels'' from **Endless**, 1984–1985
A portfolio of eleven etchings with solvent lift, aquatint, drypoint,
 scraping, and burnishing on John Koller handmade paper
Images: 6¹⁵/₁₆ x 4¹⁵/₁₆ (17.7 x 12.5)
Sheets: 20¹/₁₆ x 15¹/₂ (51.0 x 39.4)
Edition: 38, plus 9 proofs
Printed by John Lund, Universal Limited Art Editions, Inc.
Published by Universal Limited Art Editions, Inc., West Islip, New York

62. Frontispiece for **Wallace Stevens: Poems**, 1985
Etching, aquatint, openbite, and drypoint on English mould-made T.
 Edmonds paper
Sheet: 11³/₄ x 8³/₈ (30.0 x 21.3)
Book: 12¹/₈ x 9 (30.7 x 23.0)
Edition: 326 (numbered 1–300; A–Z)
Printed by John Lund and Craig Zammiello, Universal Limited Art
 Editions, Inc., West Islip, New York
Letterpress printed under direction of Andrew Hoyem, Arion Press
Bound by Schuberth Bookbindery, San Francisco
Published by Arion Press, San Francisco

Dennis Kardon

63. **Charlotte's Gaze**, 1985
Lithograph and woodcut on Gasen natural paper
Image and sheet: 24⁷/₈ x 27³/₁₆ (63.2 x 69.1)
Edition: 38, plus 23 proofs
Printed by David Keister and David Calkins, Echo Press
Published by Echo Press, Bloomington, Indiana

64. **Pleasure and Power—Second State**, 1987
Lithograph on Korean Kozo paper
Image and sheet: 25¹/₈ x 30⁵/₈ (63.8 x 77.8)
Edition: 16, plus 9 proofs
Printed by David Keister and David Calkins, Echo Press
Published by Echo Press, Bloomington, Indiana

Alex Katz

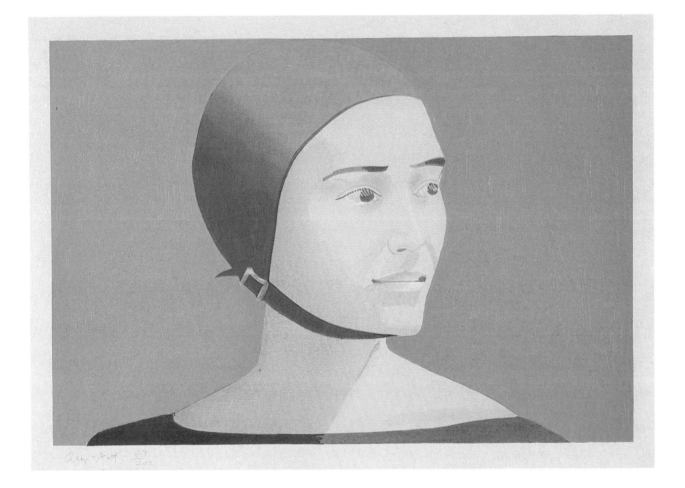

65. **The Green Cap**, 1985
Woodcut on Tosa Kozo paper
Image: 12³/16 x 17 ¹⁵/16 (30.9 x 45.5)
Sheet: 17¹³/16 x 24¹/4 (45.1 x 61.9)
Edition: 200, plus 35 proofs
Printed by Tadashi Toda, Shi-un-do Print Shop, Kyoto, Japan, with
 coordination by Hidekatsu Takada
Published by Crown Point Press, Oakland, California

Ellsworth Kelly

Per Kirkeby

66. **Concorde II (State)**, 1981–1982
Etching and aquatint with plate tone on Velin Arches paper
Image: 16³/4 x 11¹/8 (42.6 x 28.3)
Sheet: 32⁷/8 x 25³/16 (83.5 x 64.0)
Edition: 18, plus 19 proofs
Printed by Sarah Todd, Gemini G.E.L.
Published by Gemini G.E.L., Los Angeles

67. **Prototyper**, 1983
Bound volume of eighteen etchings with aquatint and drypoint on
160g. Arches paper
Sheet: 15¹/8 x 11³/16 (38.4 x 28.4)
Book: 15³/8 x 11³/4 (39.1 x 29.8)
Edition: 19
Printed by Niels Borch Jensen, Copenhagen
Bound by Gitte Ottesen
Published by Niels Borch Jensen and Susanne Ottesen, Copenhagen

Gustav Kluge

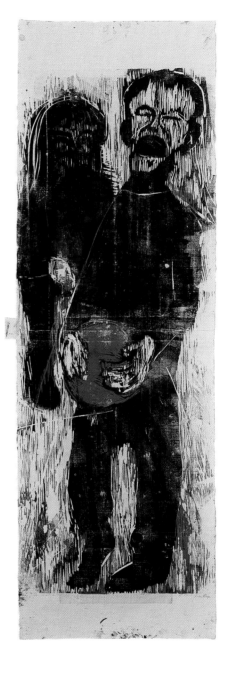

68. **Die Nachtschwester (The Night Nurse)**, 1984
Woodcut with painted additions on wrapping paper
Image: 33¹/₈ x 20⁷/₈ (84.1 x 53.0)
Sheet: 34⁹/₁₆ x 24³/₄ (87.8 x 62.9)
Edition: unique, plus a few proofs
Printed and published by the artist, Hamburg

69. **Der Junge mit der roten Plastikschüssel (The Boy with the Red Plastic Dish)**, 1985
Woodcut on two sheets of Japan paper
Image: 64⁷/₈ x 25⁹/₁₆ (164.7 x 65.0)
Sheet: 76³/₁₆ x 25⁹/₁₆ (193.4 x 65.0)
Edition: one of a series of three unique prints plus a few proofs
Printed and published by the artist, Hamburg

Oleg Kudryashov

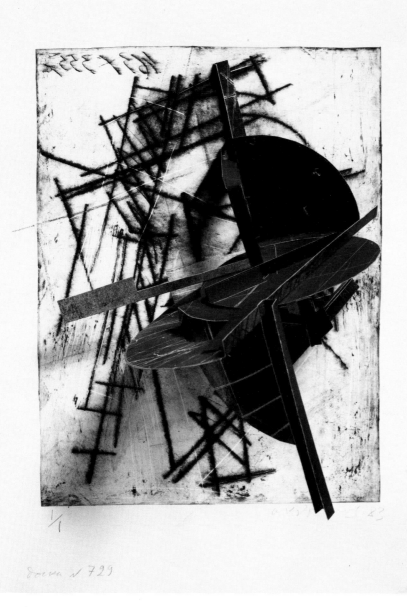

70. **Construction, plate no. 729**, 1983
Three-dimensional drypoint with painted additions on Arches paper
Image: 17³/4 x 13⁷/8 (45.2 x 35.5)
Sheet: 23¹³/16 x 18¹/2 x 11¹/2 (60.3 x 47.0 x 29.2)
Edition: unique
Printed and published by the artist, London

Mark Leithauser

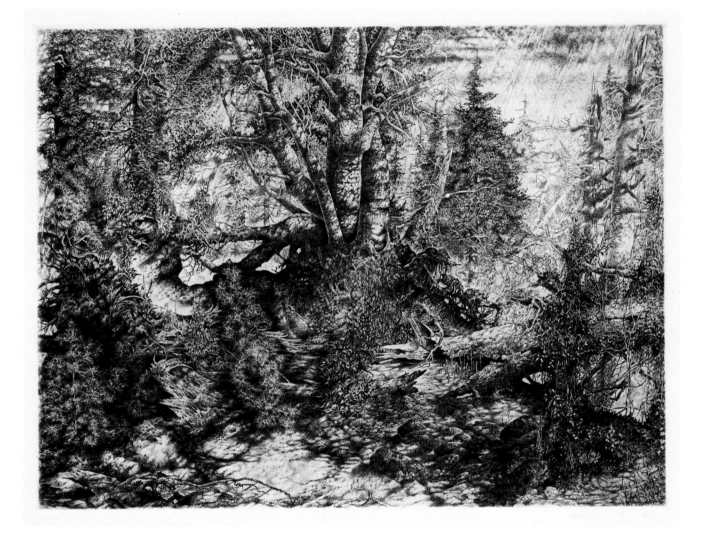

71. **Birches**, 1980
Etching on Arches paper
Image: 11¹¹/₁₆ x 15³/₄ (29.7 x 40.0)
Sheet: 17¹/₈ x 20⁷/₈ (43.5 x 53.0)
Edition: 125, plus 20 proofs
Printed and published by the artist, Washington, D.C.

Robert Longo

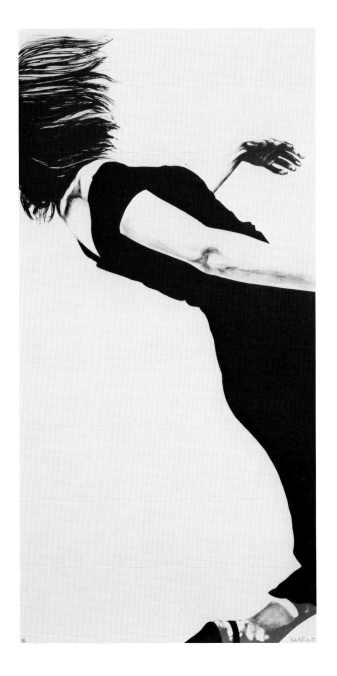

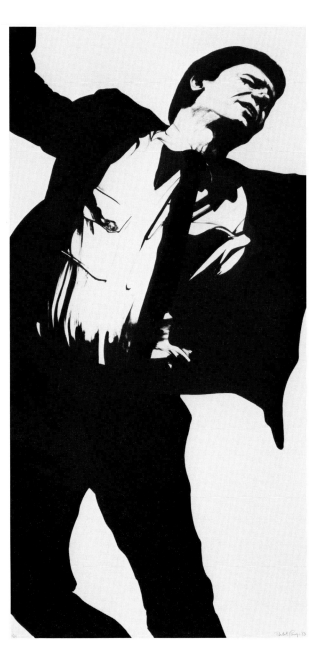

72. **Men in the Cities: Joanna**, 1983
Lithograph on 350g. Arches paper
Image and sheet: 72 x 36 (182.8 x 91.5)
Edition: 48, plus 11 proofs
Printed by Maurice Sanchez, Derrière L'Etoile Studios, New York
Published by Editions Schellmann & Klüser, Munich

73. **Men in the Cities: Larry**, 1983
Lithograph on Arches 350g. paper
Image and sheet: 72 x 36 (182.8 x 91.5)
Edition: 48, plus 11 proofs
Printed by Maurice Sanchez, Derrière L'Etoile Studios, New York
Published by Editions Schellmann & Klüser, Munich

Markus Lüpertz

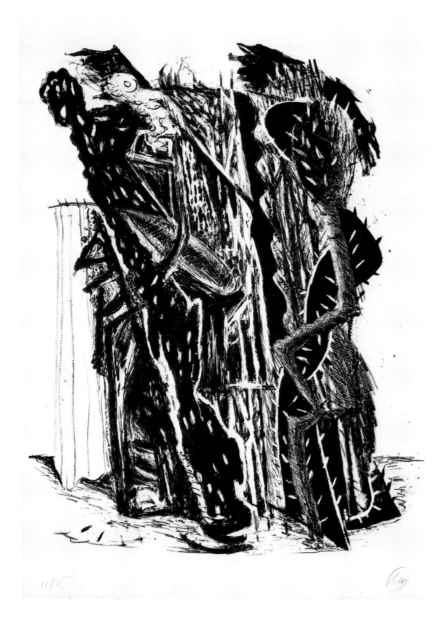

74. Number II from **Sieben über ML (Seven about ML)**, 1980
A portfolio of seven lithographs on 250g. Velin Arches paper
Image and sheet: 31¾ x 22½ (80.7 x 57.2)
Edition: 35, plus 5 proofs
Printed by Clot Bramsen and Georges, Paris
Published by Galerie Heiner Friedrich, Munich

Robert Mangold

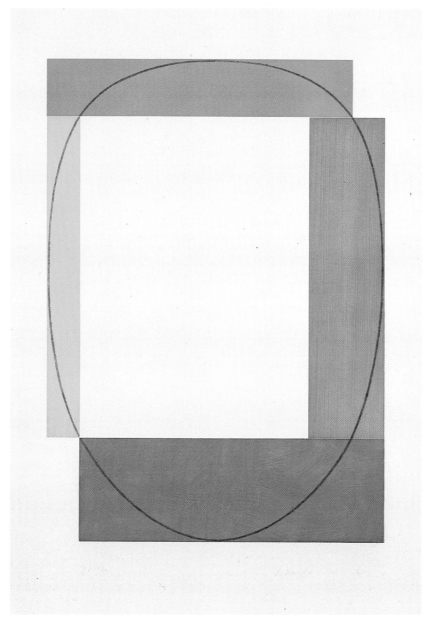

75. **Untitled**, 1985
One of two etchings and aquatints, Two Aquatints, on Somerset
 Satin paper
Image: 41⁷/₈ x 30¹/₂ (106.3 x 77.5), irregular
Sheet: 53 x 37⁷/₁₆ (134.6 x 95)
Edition: 20, plus 12 proofs
Printed by Doris Simmelink and Jeryl Parker, Jeryl Parker Editions,
 New York
Published by Parasol Press, New York

Paul Marcus

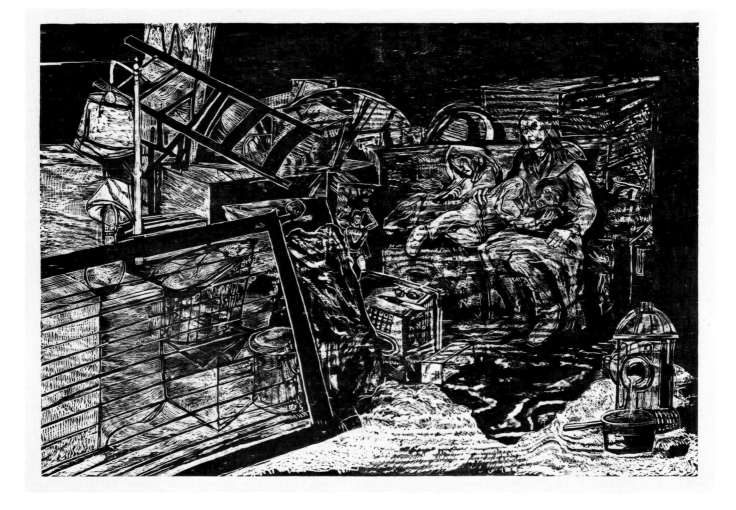

76. **The Eviction**, 1985
Woodcut with drawn additions on Aquaba paper
Image: 48 x 71³/4 (121.9 x 182.2)
Sheet: 55 x 77³/4 (139.7 x 197.5)
Edition: 4
Printed and published by the artist, Pycus Studio, New York

Brice Marden

Michael Mazur

77b

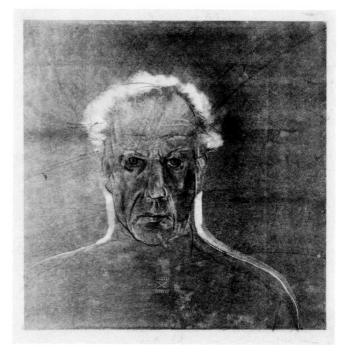

77a., b. Numbers 17 and 18 from **Etchings to Rexroth**, 1986
A portfolio of twenty-five etchings with sugarlift, aquatint, open
 bite, drypoint, and scraping on Rives BFK paper
Images: 8 x 6⅞ (20.3 x 17.5)
Sheets: 19⁹/₁₆ x 15⅞ (49.7 x 40.3)
Edition: 45, plus 10 Roman numeraled copies
Printed by Jennifer Melby, New York
Published by Peter Blum Edition, New York

78. **S.P. 1/9/85 A**, 1985
Monotype on oriental paper
Image: 18 x 18 (45.7 x 45.7)
Sheet: 30¼ x 22¼ (76.8 x 56.5)
Edition: unique
Printed and published by the artist, Boston

Michael Mazur

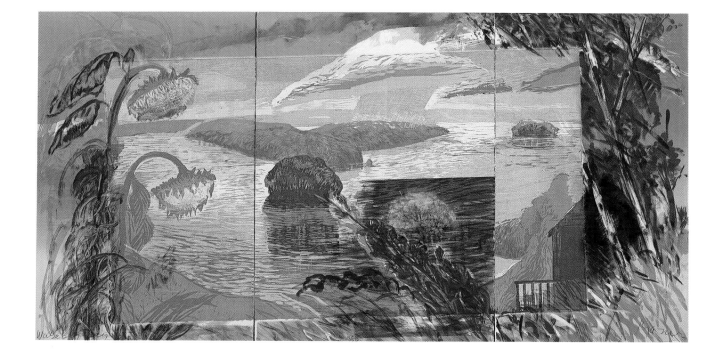

79. **Wakeby Day**, 1986
Lithograph, woodcut, and monoprint, with chine collé of Sekishu
 paper on three sheets of Arches paper
Left image and sheet: 30¹/₈ x 20³/₈ (76.5 x 51.9)
Center image and sheet: 30¹/₈ x 22³/₈ (76.5 x 56.8)
Right image and sheet: 30 x 18¹/₈ (76.2 x 46.1)
Edition: 50, plus 14 proofs
Printed by Judith Solodkin, Toshiyasu Shinozaki, Dan Stack, David
 Belzycki, and Brian Finley, Solo Press
Co-published by Joe Fawbush Editions and Solo Press, New York

George McNeil

Melissa Meyer

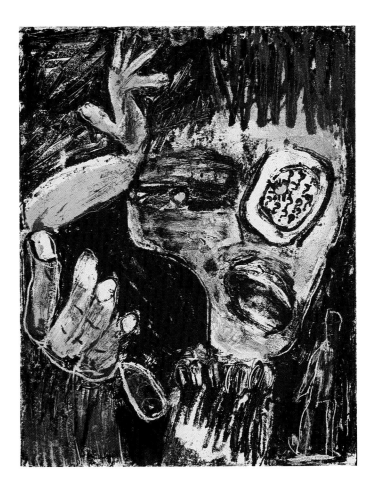

80. **I Wonder!**, 1985
Lithograph on Rives BFK paper
Image and sheet: 28 x 22⁹/₁₆ (71.1 x 57.2)
Edition: 15, plus a few proofs
Printed and published by the artist, Brooklyn

81. "Daphne" from **Ovid**, 1984–1987
A series of four etchings and aquatints with scraping on Arches
 paper
Image: 9⁵/₈ x 6 (24.5 x 15.2)
Sheet: 26 ¹⁵/₁₆ x 19⁹/₁₆ (68.4 x 49.7)
Edition: 10, plus 16 proofs
Printed by Jane Kent, New York
Published by R. C. Erpf Gallery, New York

Richard Mock

Malcolm Morley

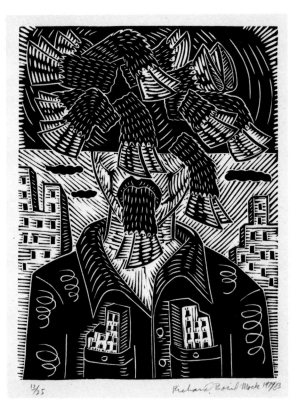

82. Hoof Man, 1979–1983
Linocut on Chiffon paper
Image: 17³/₁₆ x 12 ¹⁵/₁₆ (43.7 x 32.9)
Sheet: 24 x 19 ¹⁵/₁₆ (61.0 x 50.7)
Edition: 25, plus 11 proofs
Printed by Victoria Sclafani, Solo Press
Published by Solo Press, New York

83. Goats in a Shed, 1982
Lithograph on handmade Nimaizuki paper
Image: 28¹/₁₆ x 39¹/₂ (71.2 x 100.3)
Sheet: 28³/₄ x 40 (73.0 x 101.6)
Edition: 30, plus 20 proofs
Printed by Roger Campbell and Lee Funderburg with processing by
 Kenneth Tyler, Tyler Graphics Ltd.
Published by Tyler Graphics Ltd., Bedford Village, New York

Elizabeth Murray

Bruce Nauman

84. **Snake Cup**, 1984
Lithograph on Velin Arches paper
Image and sheet: 32⅛ x 25 (81.6 x 63.5)
Edition: 40, plus 27 proofs
Printed by James Miller, Maurice Sanchez, and John Volny, Derrière
 L'Etoile Studios, New York
Co-published by Brooke Alexander, Inc. and Paula Cooper Gallery,
 New York

85. **House Divided**, 1983
Drypoint and etching on Fabriano Rosaspina paper
Image: 23⅞ x 32¾ (60.8 x 83.1)
Sheet: 28⅛ x 39¼ (71.4 x 99.7)
Edition: 23, plus 13 proofs
Printed by Doris Simmelink, Gemini G.E.L.
Published by Gemini G.E.L., Los Angeles

John Newman

86. **Two Pulls**, 1986
Soft- and hardground etching, aquatint, and drypoint on T. H.
 Saunders paper
Image and sheet: 45 1/4 x 25 3/16 (114.8 x 64.0)
Edition: 39, plus 6 proofs
Printed by Jennifer Melby, New York
Published by Editions Ilene Kurtz, New York

Hermann Nitsch

87. **Das letzte Abendmahl (The Last Supper)**, 1983
Screenprint on stained canvas with painted additions
Image and sheet: 64¼ x 160¼
Edition: 25
Printed by Edition Francesco Conz, Verona
Published by the artist, Prinzendorf, Austria

Mimmo Paladino

Jürgen Partenheimer

88. **Muto (Mute)**, 1985
Etching, sugarlift, and aquatint with seal fur collage on Velin Arches
 paper
Image: 58½ x 29⁹/₁₆ (148.6 x 75.2), irregular
Sheet: 61⅝ x 34½ (156.5 x 87.7)
Edition: 35, plus 13 proofs
Printed by Felix Harlan and Carol Weaver, Harlan & Weaver Intaglio,
 with ears sewn by Lori Haselrick, New York
Published by Editions Schellmann, New York

89. **Book of Wanderings**, 1983
A portfolio of twelve etchings on Rives paper
Sheet: 9¾ x 6⅛ (24.8 x 15.5)
Book: 9¹³/₁₆ x 6¼ (24.9 x 15.7)
Edition: one of two variant copies
Printed and published by the artist, San Francisco

A. R. Penck

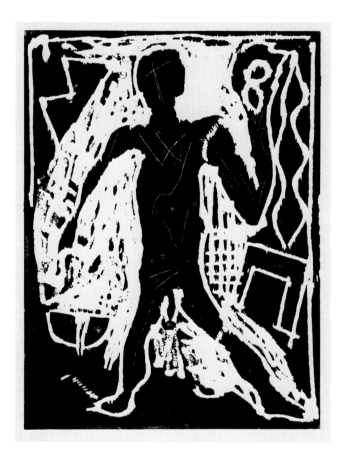

90. "Die Arbeit geht weiter" ("The Work Continues") from
 Portfolio I of **Erste Konzentration** (First Concentration), 1982
A portfolio of twelve prints by various artists, this one a woodcut on
 handmade copperplate paper
Image: 35½ x 27⅜ (90.1 x 69.6)
Sheet: 39⅜ x 30¾ (100.0 x 78.1)
Edition: 50, plus 8 Roman numeraled copies and several proofs
Printed by Karl Imhof, Munich
Published by Maximilian Verlag-Sabine Knust, Munich

91. **Standart West K (Standard West K)**, 1982–1985
Drypoint and etching on handmade paper
Image and sheet: 32¹³/₁₆ x 25⅛ (83.3 x 63.8)
Edition: unique proof of sixth state before an edition of 10
Printed by Karl Imhof, Munich
Published by Maximilian Verlag-Sabine Knust, Munich

Howardena Pindell

Arnulf Rainer

92. **Kyoto: Positive/Negative**, 1980
Etching and lithograph on dyed Japan paper with five sheets of
 laminated Kinwashi paper
Image and sheet: 26½ x 20⅝ (67.3 x 52.4), irregular
Edition: 30, plus 13 proofs
Etching printed by Patricia Branstead, Aeropress, New York;
 lithography printed by Judith Solodkin, Solo Press, New York
Published by Bristol Art Editions, New York

93. **Blue Cross**, 1981
Drypoint on Arches paper
Image: 12¹³/₁₆ x 8⅝ (32.5 x 21.9), irregular
Sheet: 21⅛ x 15½ (53.7 x 39.4)
Edition: 35
Printed by Karl Imhof, Munich
Published by Maximilian Verlag-Sabine Knust, Munich

Robert Rauschenberg

94. **Bellini #1**, 1986
Continuous-tone gravure on Arches paper
Image: 55³/₄ x 34⁷/₈ (141.5 x 88.5)
Sheet: 58¹/₄ x 38¹/₁₆ (147.9 x 96.9)
Edition: 36, plus 8 proofs
Printed by Craig Zammiello, Universal Limited Art Editions, Inc.
Published by Universal Limited Art Editions, Inc., West Islip, New York

Susan Rothenberg

95. **Pinks**, 1980
Monoprint woodcut on Umbria paper
Image: 11⅛ x 20⅜ (28.2 x 51.8)
Sheet: 19⅞ x 28⅛ (50.5 x 71.5)
Edition: 20, plus 13 proofs
Printed by Gretchen Gelb, Aeropress, New York
Published by Multiples, Inc., New York

96. **Stumblebum**, 1985–1986
Lithograph on Arches paper
Image and sheet: 86¾ x 42½ (220.2 x 107.9)
Edition: 40, plus 8 proofs
Printed by Keith Brintzenhofe, William Goldston, and Douglas Volle,
 Universal Limited Art Editions, Inc.
Published by Universal Limited Art Editions, Inc., West Islip, New York

Edward Ruscha

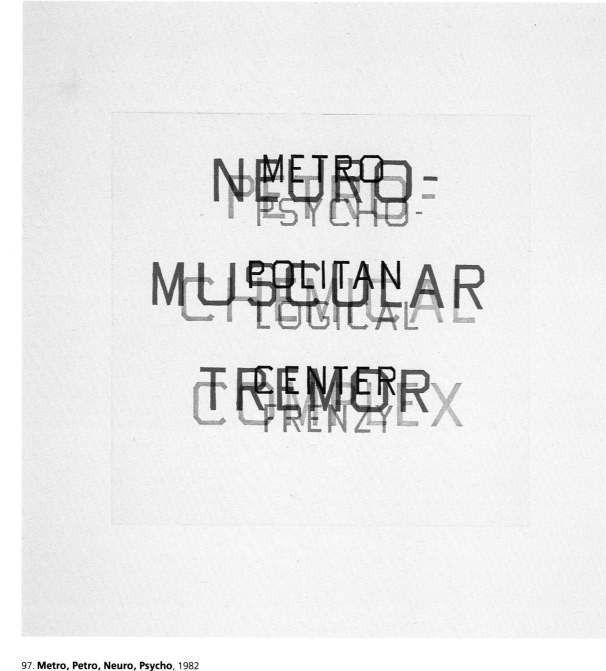

97. **Metro, Petro, Neuro, Psycho**, 1982
Softground etching on Somerset Satin paper
Image: 14¹/₂ x 15¹/₄ (36.8 x 38.7)
Sheet: 24³/₁₆ x 22³/₈ (61.5 x 56.8)
Edition: 25, plus 14 proofs
Printed by Peter Pettengill assisted by Marcia Bartholme, Crown
 Point Press
Published by Crown Point Press, Oakland, California

David Salle

98. ''Untitled'' from **Theme for an Aztec Moralist**, 1983–1984
A suite of six lithographs on 350g. Velin Arches paper
Image and sheet: 46 x 34 (116.9 x 86.4)
Edition: 40, plus 11 proofs
Printed by Maurice Sanchez, James Miller, John Volny, Gwen
 Wyman, with special consultant Joe Petrozelli, Derrière L'Etoile
 Studios, New York
Published by Editions Schellmann & Klüser, Munich

99. ''Untitled'' from **Grandiose Synonym for Church**, 1985
A suite of eight etchings with sugarlift, aquatint, spitbite, and
 softground on Somerset paper
Image: 47⅞ x 37¹¹/₁₆ (121.4 x 95.8)
Sheet: 60¾ x 47¹⁵/₁₆ (154.4 x 121.8)
Edition: 17, with 11 proofs
Printed by Brenda Zlamany assisted by Joanne Howard, Jeryl Parker
 Editions, New York
Published by Parasol Press, New York

Sean Scully

100. **Conversation**, 1986
Woodcut on Okawara paper
Image: 30 1/8 x 44 7/8 (76.5 x 114.0)
Sheet: 37 1/8 x 53 1/2 (94.3 x 135.9)
Edition: 40, plus 12 proofs
Proofed by Chip Elwell and printed by Andrew Bovell, New York
Published by Diane Villani Editions, New York

Joel Shapiro

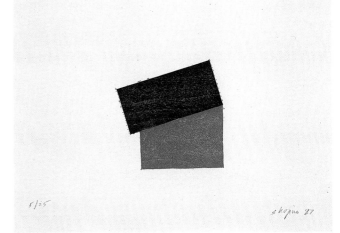

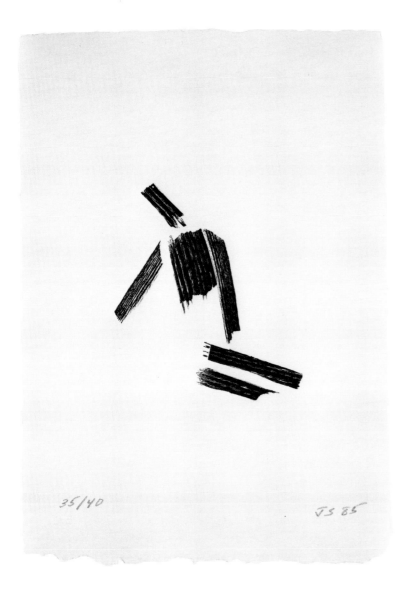

101. Untitled No. 1, 1985
Wood collage print on handmade paper
Image and sheet: 12¼ x 8⅝ (31.1 x 21.9)
Edition: 40, plus 11 proofs
Printed by Keith Brintzenhofe, Universal Limited Art Editions, Inc.
Published by Universal Limited Art Editions, Inc., West Islip, New York

102. Untitled, 1987, issued with **Rift**, 1986
Written by Peter Cole
Woodcut on handmade Whatman paper
Sheet: 10½ x 7 (26.7 x 17.8)
Book: 10¹¹⁄₁₆ x 7¹⁄₁₆ (27.1 x 17.9)
Edition: 150 (numbered 1–135, I–XV; this copy from the Roman
 numeraled edition, issued with a separate woodcut in an
 edition of 25 plus 4 proofs on Crown & Sceptre paper, dated
 1987)
Letterpress printed by Leslie Miller, New York; bound by Claudia
 Cohen
Published by The Grenfell Press, New York

Joan Snyder

T. L. Solien

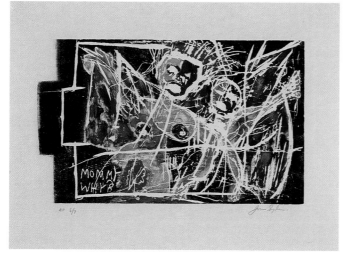

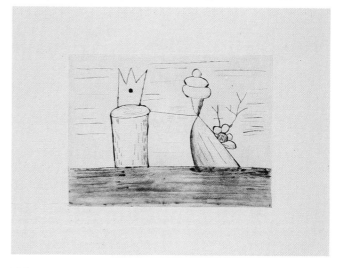

104b

103. Mommy Why?, 1984
Monoprint woodcut on Yamoto paper
Image: 11¹⁵/₁₆ x 20⅛ (30.3 x 51.2), irregular
Sheet: 18¾ x 25⅜ (47.6 x 64.4)
Edition: 15, plus 7 proofs
Printed by Chip Elwell, New York
Published by Diane Villani Editions, New York

104. Fragments of Hope, 1982
A portfolio of five drypoints on handmade paper
Sheets: 13¾ x 17¼ (34.9 x 43.8)
Images:
a. Title Page: 10¾ x 10¾ (19.8 x 27.4)
b. "Sunken Treasure": 7¾ x 10¾ (19.8 x 27.4)
c. "Boatman's Rescue": 7¾ x 11 (19.8 x 27.9)
d. "Tower of Strength": 7¾ x 10¾ (19.8 x 27.4)
e. "Handle and Tow": 7¾ x 11 (19.8 x 27.9)
f. "Memoir Den": 8 x 10¾ (20.4 x 27.4)
Edition: 21, plus 8 proofs
Printed by Steven Andersen, Vermillion Editions Ltd.
Published by Vermillion Editions Ltd., Minneapolis, Minnesota

Steven Sorman

Pat Steir

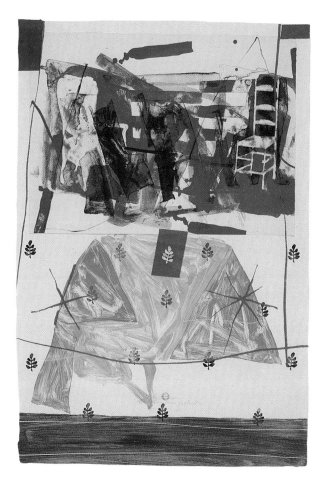

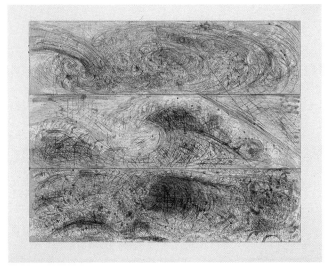

105. The Letter from Matisse, 1982
Lithograph, screenprint, rubber stamp, monotype, collage, with
 chine collé of Arte paper on Japanese etching paper
Image and sheet: 36 x 24¹⁄₂ (91.3 x 61.7)
Edition: 25, plus 12 proofs
Printed by Steven Andersen at Atelier Arté, Paris, and Vermillion
 Editions Ltd., Minneapolis
Co-published by Vermillion Editions Ltd., Minneapolis, and the
 American Center, Paris

**106. The Wave—From the Sea—After Leonardo, Hokusai,
 & Courbet**, 1985
Aquatint, softground, hardground, drypoint, and soapground on
 Somerset Satin paper
Image: 35³⁄₈ x 44⁷⁄₈ (90.0 x 113.8)
Sheet: 42¹⁄₈ x 52³⁄₈ (107.0 x 133.1)
Edition: 50, plus 32 proofs
Printed by Hidekatsu Takada, assisted by Marcia Bartholme,
 Lawrence Hamlin and Renée Bott, Crown Point Press
Published by Crown Point Press, Oakland, California

Frank Stella

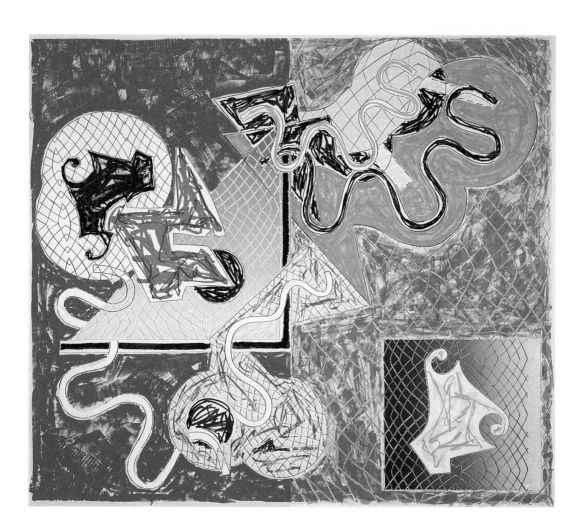

107. **Shards IV**, 1982
Lithograph and screenprint on Velin Arches paper
Image and sheet: 39¾ x 45¼ (101.0 x 114.9)
Edition: 100, plus 31 proofs
Printed by John Hutcheson, James Welty, Spencer Tomkins and
 Norman Lassiter, Petersburg Press, Inc.
Published by Petersburg Press, Inc., London and New York

David Storey

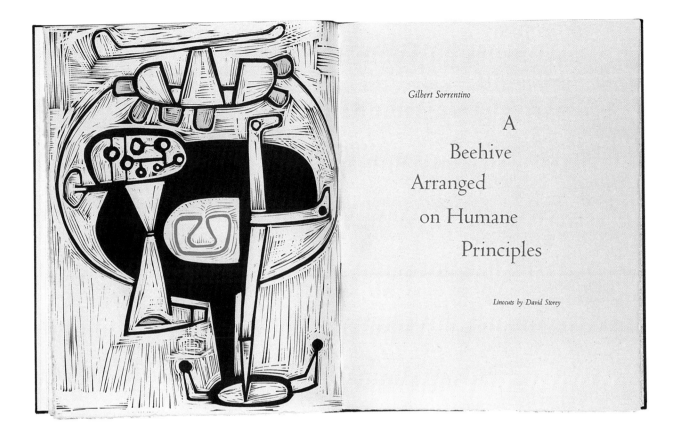

Gilbert Sorrentino

A
Beehive
Arranged
on Humane
Principles

Linocuts by David Storey

108. Frontispiece to **A Beehive Arranged on Humane
 Principles**, 1986
Written by Gilbert Sorrentino
Four linocuts on J. Whatman 1954 paper, plus a linocut on the cover
 of the volume
Sheet: 10⁵/₈ x 8³/₁₆ (27.0 x 20.8)
Book: 10¹³/₁₆ x 8³/₄ (27.5 x 22.2)
Edition: 85 (numbered 1–70, I–XV)
Letterpress printed by Leslie Miller, The Grenfell Press, New York;
 bound by Claudia Cohen
Published by The Grenfell Press, New York

Donald Sultan

109. **Smokers**, 1980
A set of three aquatints with scraped and burnished areas, drypoint,
 mezzotint, and hardground on Rives BFK paper
Each image and sheet: 41½ x 41½ (105.4 x 105.4)
Edition: 10, plus 14 proofs
Printed by Hidekatsu Takada and Lilah Toland, Crown Point Press,
 Oakland, California
Published by Parasol Press, New York

Donald Sultan

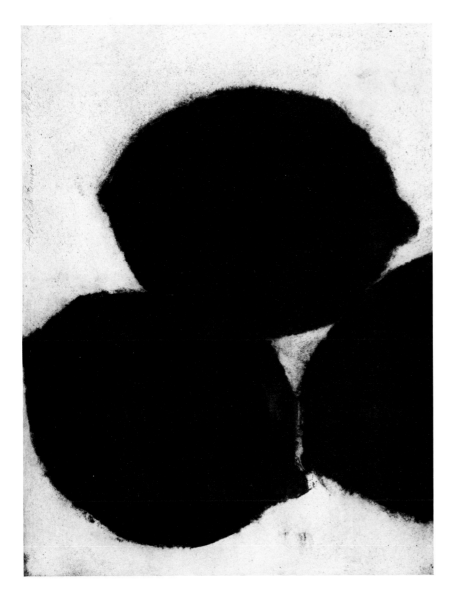

110. **Black Lemons, November 30, 1984**, 1984
One of four aquatints with open bite, Black Lemons, on Somerset
 Satin paper
Image: 61⁹/₁₆ x 47¼ (156.3 x 120.0)
Sheet: 62¹⁵/₁₆ x 48½ (159.9 x 123.2)
Edition: 10, plus 12 proofs
Printed by Brenda Zlamany and Joanne Howard, Jeryl Parker
 Editions, New York
Published by Parasol Press, New York

James Turrell

Richard Tuttle

111. Deep Sky, 1984
Seven aquatints on Rives BFK paper
Images: 12⁵/₈ x 19⁷/₁₆ (32.1 x 49.3)
Sheets: 21¹/₈ x 27¹/₁₆ (53.7 x 68.7)
Edition: 45, plus 10 proofs
Printed by Peter Kneubühler, Zurich
Published by Peter Blum Edition, New York

112. Hiddenness, 1987
Written by Mei-mei Berssenbrugge
Lithography, screenprint and hand-stamping in an accordion format on Paul
 Wong's handmade paper, made at Dieu Donne Papermill, New York
Sheet: 15 x 10¹/₄ (38.1 x 26.1)
Book: 15¹/₂ x 10 (39.4 x 25.4)
Edition: 120, plus several proofs
Lithography printed by Judith Solodkin and hand-stamping by Cinda Sparling,
 Solo Press, New York; screenprint by Larry B. Wright, New York
Letterpress set by Michael and Winifred Bixler, Skaneateles, New York,
 and printed by Peter Kruty, Solo Press, New York; bound by George
 and Catherine Wieck, Moroquain, Inc., Hopewell Junction, New York
Published by the Library Fellows of the Whitney Museum of
 American Art, New York

Not Vital

113. Snowblind, 1987
Media as listed below, on seven sheets of Fabriano Tiepolo paper
a: Relief printing, lift ground aquatint, and embossing
 Image and sheet: 32⁷/8 x 26⁵/8 (83.5 x 67.6)
b: Lift ground aquatint
 Image and sheet: 16¹/2 x 13⁷/8 (41.9 x 35.2)
c: Lift ground aquatint
 Image and sheet: 16⁹/16 x 13⁷/8 (42.1 x 35.2)
d: Relief print on silver foil on chine collé
 Image: 13¹⁵/16 x 11¹/16 (35.4 x 28.0)
 Sheet: 17¹/16 x 14¹/16 (43.3 x 35.9)

e: Monoprint
 Image and sheet: 17¹/16 x 14¹/8 (43.3 x 35.9)
f: Photo etching
 Image: 5⁷/16 x 3⁷/8 (13.8 x 9.9)
 Sheet: 7⁷/16 x 6 (18.9 x 15.2)
g: Lift ground aquatint
 Image and sheet: 23⁵/16 x 12¹/4 (59.2 x 31.1)
Edition: 23, plus 4 Roman numeraled copies and 7 proofs
Printed by Donna Shulman, Downstairs Editions, Brooklyn
Published by Baron/Boisanté Editions, New York

William T. Wiley

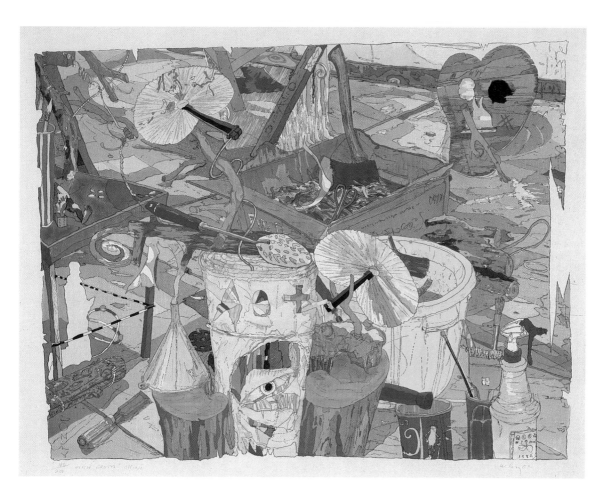

114. **Eerie Grotto? Okini**, 1982
Woodcut on Echizen-Hosho paper
Image: 20⅝ x 27 (52.5 x 69.0), irregular
Sheet: 22³/₁₆ x 29⅜ (57.7 x 74.8)
Edition: 200, plus 28 proofs
Printed by Tadashi Toda, Shi-un-do Print Shop, Kyoto, Japan
Published by Crown Point Press, Oakland, California

Terry Winters

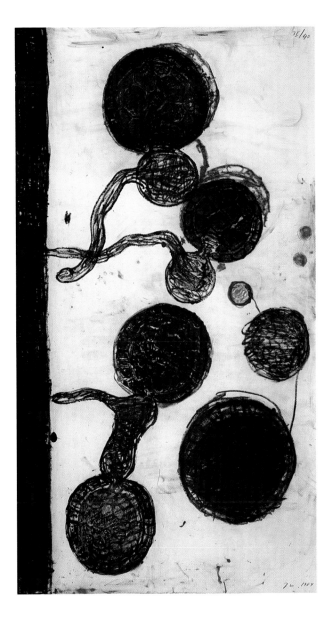

115. **Double Standard**, 1984
Lithograph on Arches paper
Image and sheet: 77³/4 x 42³/8 (197.0 x 107.7)
Edition: 40, plus 8 proofs
Printed by John Lund and Douglas Volle, Universal Limited Art
 Editions, Inc.
Published by Universal Limited Art Editions, Inc., West Islip, New York

116. **Primer**, 1985
Lithograph on J. Whatman 1961 paper
Image and sheet: 31⁵/16 x 23 (79.5 x 58.5)
Edition: 66, plus 12 proofs
Printed by Keith Brintzenhofe, Universal Limited Art Editions, Inc.
Published by Universal Limited Art Editions, Inc., West Islip, New York

Troels Wörsel

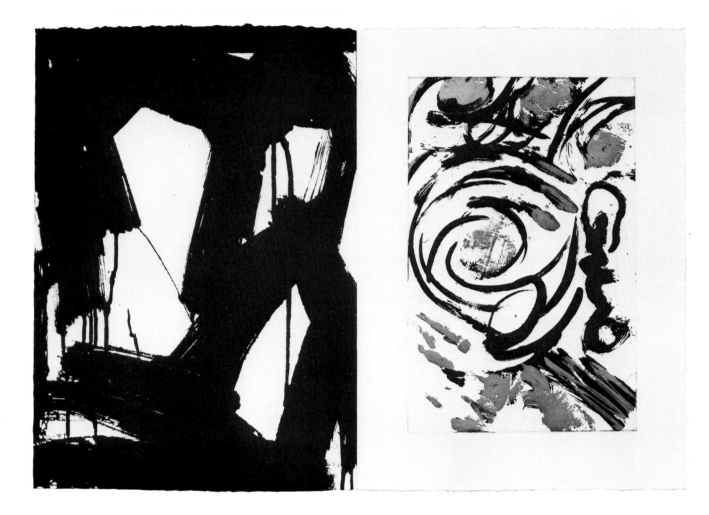

117. Number XI from **Die Grundlagen der Arithmetik (The
 Foundations of Arithmetic)**, 1980
A portfolio of nineteen prints in a folio format issued with a separate
 volume of text by Gottlob Frege
Etching and aquatint on 250 g. Zerkall paper
Overall image and sheet: 12⅝ x 18¹¹/₁₆ (32.0 x 47.4); plate on right
 page measures 9¾ x 16⁷/₁₆ (24.7 x 16.5)
Book: 8¼ x 5½ x ⅜ (20.8 x 14.0 x .08)
Edition: 25, plus 2 complete proof sets and a few of individual
 sheets
Printed by Niels Borch Jensen, Copenhagen
Prints published by Galerie Fred Jahn, Munich
Book published by Georg Olms Verlag, Hildesheim and New York

Troels Wörsel

Bernd Zimmer

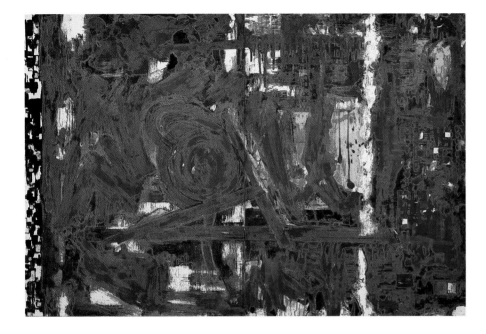

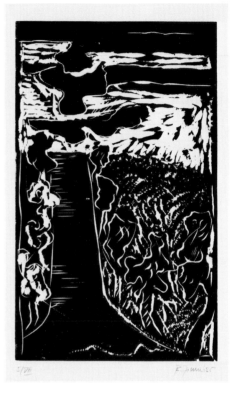

118. **Untitled**, 1984
Aquatint on two sheets of wove paper
Image and sheet: 24⅛ x 18 (61.3 x 45.7), each panel
Edition: 24, plus a few proofs
Printed by Niels Borch Jensen, Copenhagen
Published by Galerie Fred Jahn, Munich

119. "Untitled" from **Lichtsplitter** (**Light Fragments**), 1985
A portfolio of eight woodcuts on handmade paper, this copy with
 one gouache study
Image: 15 x 9¼ (38.1 x 23.5)
Sheet: 25½ x 18⅞ (64.7 x 47.9)
Edition: 27, plus 8 Roman numeraled copies
Printed by Karl Imhof, Munich
Published by Galerie Hermeyer, Munich

Artists' Biographies and Bibliographies

Gregory Amenoff

Born:
St. Charles, Illinois, 1948

Lives:
New York, New York

Education:
Beloit College, Beloit, Wisconsin, B.A., 1970.

Bibliography:
Baker, Kenneth. *Gregory Amenoff.* Exh. cat., Robert Miller Gallery. New York, 1983.
Pentak, Stephen. "Gregory Amenoff's New Pictures: Feeling Given Form." *Arts Magazine* 56 (November 1981): 156–57.
Pincus-Witten, Robert. *Gregory Amenoff.* Exh. cat., Hirschl & Adler Modern. New York, 1987.
Simmons, Chuck. "Exhibitions: In The Fifth Season." *Artweek* 14 (April 16, 1983): 6.
Tsujimoto, Karen. *Gregory Amenoff.* Exh. cat., Stephen Wirtz Gallery. San Francisco, 1986.

Ida Applebroog

Born:
Bronx, New York, 1929

Lives:
New York, New York

Education:
New York State Institute of Applied Arts and Sciences, Brooklyn, New York, 1947–1950.
School of the Art Institute of Chicago, Chicago, Illinois, 1956–1961.

Bibliography:
Bass, Ruth. "New Editions." *ARTnews* 85 (March 1985): 68.
Bass, Ruth. "Ordinary People." *ARTnews* 87 (May 1988): 151–154.
Cohen, Ronny H. "Ida Applebroog: Her Books." *The Print Collector's Newsletter* 15 (May–June 1984): 49–51.
Hess, Elizabeth. "Beyond Domestic Agony." *The Village Voice* (10 November 1987): 101.
Morgan, Susan. "And that's the way it is . . . The Works of Applebroog, Diamond and Wegman." *Artscribe* 58 (June–July 1986): 48–49.

Richard Artschwager

Born:
Washington, D.C., 1923

Lives:
New York, New York

Education:
Cornell University, Ithaca, New York, B.A., 1942.
Studied with Amédée Ozenfant, 1949–1950.

Bibliography:
Armstrong, Richard. *Richard Artschwager.* Exh. cat., Whitney Museum of American Art. New York, 1988.
Baro, Gene. *Twenty-Second National Print Exhibition.* Exh. cat., The Brooklyn Museum. Brooklyn, 1981: 19.
Richard Artschwager: Beschreibungen, Definitionen, Auslassungen. Exh. cat., Kunstverein in Hamburg. Hamburg, 1978.
Richard Artschwager's Theme(s). Exh. cat., Albright-Knox Art Gallery. Buffalo, New York, 1979.
van Bruggen, Coosje. "Richard Artschwager." *Artforum* 22 (September 1983): 44–51.

Donald Baechler

Born:
Hartford, Connecticut, 1956

Lives:
New York, New York

Education:
Maryland Institute, College of Art, Baltimore, Maryland, 1974–1977.
Cooper Union for The Advancement of Science and Art, New York, New York, 1977–1978.
Staatliche Hochschule für bildende Künste, Frankfurt-am-Main, Federal Republic of Germany, 1978–1979.

Bibliography:
Dickhoff, Wilfried. *Donald Baechler.* Exh. cat., Tony Shafrazi Gallery. New York, 1985.
Donald Baechler: Hamburger Gemälde. Exh. cat., Galerie Ascan Crone. Hamburg, 1985.
Jones, Alan. "Donald Baechler." *Arts Magazine* 57 (March 1983): 5.
Pincus-Witten, Robert. *Donald Baechler: Increments of Inaccessibility.* Exh. cat., Tony Shafrazi Gallery. New York, 1983.
Taylor, Paul. "Donald Baechler" (an interview with the artist). *Flash Art* 136 (October 1987): 90–91.

Jennifer Bartlett

Born:
Long Beach, California, 1941

Lives:
New York, New York; Paris, France

Education:
Mills College, Oakland, California, B.A., 1963.
Yale University, School of Art and Architecture, New Haven, Connecticut, B.F.A., 1964, M.F.A., 1965.

Bibliography:
Field, Richard S. "Jennifer Bartlett: Prints, 1978–1983." *The Print Collector's Newsletter* 15 (March–April 1984): 1–6.
Goldwater, Marge, Roberta Smith, and Calvin Tomkins. *Jennifer Bartlett.* Exh. cat., Walker Art Center. Minneapolis, 1985. New York: Abbeville Press, 1985.
Robertson, Nan. "In the Garden with Jennifer Bartlett." *ARTnews* 82 (November 1983): 72–77.
Russell, John. *Jennifer Bartlett: In the Garden.* New York: Harry N. Abrams, Inc., 1982.
Tomkins, Calvin. "Profiles: Getting Everything In." *New Yorker* (22 April 1985): 50–68.

Georg Baselitz

Born:
Deutschbaselitz, Germany, 1938

Lives:
Derneburg, Federal Republic of Germany

Education:
Hochschule für bildende und angewandte Kunst, East Berlin, 1956–1957.
Hochschule für bildende Kunst, West Berlin, 1957–1964.

Bibliography:
Baselitz, Georg, Siegfried Gohr, and Rainer Michael Mason. *Georg Baselitz: Gravures 1963–1983*. Exh. cat., Cabinet des Estampes, Musée d'Art et d'Histoire. Geneva, 1984.
Dietrich-Boorsch, Dorothea. "The Prints of Georg Baselitz: An Introduction." *The Print Collector's Newsletter* 12 (January–February 1982): 165–68.
Gercken, Günther. "Renaissance der Druckgraphik: Georg Baselitz, Jörg Immendorff, Markus Lüpertz, A. R. Penck." In *Druckgraphik 1970–85*, edited by Peter Pakesch. Exh. cat., Künstlerhaus Graz, Grazer Kunstverein. Graz, Austria, 1986: 43–63.
Gohr, Siegfried. *Georg Baselitz Prints 1963–1983*. Exh. cat., Staatliche Graphische Sammlung, Munich, 1984.
Lloyd, Jill. "Georg Baselitz Comes Full Circle: The Art of Transgression and Restraint." *Art International* 5 (Winter 1988): 86–96.

Mark Beard

Born:
Salt Lake City, Utah, 1956

Lives:
New York, New York

Education:
University of Utah, Salt Lake City, Utah, B.F.A., 1979.

Bibliography:
Feingold, Michael, and Carla Schulz-Hoffmann. *Mark Beard: Utah-Manhattan-Zyklus*. Exh. cat., Staatsgalerie moderner Kunst. Munich, 1988.
Sussler, Betsy, and David Rattray. *Points along the Côte D'Azur Triangle* (interviews with the artist and author). Exh. cat., The Harcus Gallery. Boston and New York, 1985.

Jake Berthot

Born:
Niagara Falls, New York, 1939

Lives:
New York, New York

Education:
New School For Social Research, New York, New York, 1960–1961.
Pratt Institute, School of Art and Design, Brooklyn, New York, 1960–1962.

Bibliography:
Corbett, William. "Jake Berthot." *Art New England* 9 (July–August 1988): 35.
Elderfield, John. *New Work on Paper 1*. Exh. cat., The Museum of Modern Art. New York, 1981: 18–21.

Glueck, Grace. "Jake Berthot." *New York Times*, 25 November 1983.
Jake Berthot. Exh. cat., Rose Art Museum, Brandeis University. Waltham, Massachusetts, 1988.
Moorman, Margaret. "States of Grace," *ARTnews* 88 (January 1989): 118–22.

Jean-Charles Blais

Born:
Nantes, France, 1956

Lives:
Paris, France

Education:
École Régionale des Beaux-Arts, Rennes, France, 1974–1979.

Bibliography:
Girard, Xavier. "Entretien: Jean-Charles Blais." *Beaux Arts* 11 (March 1984): 24–29.
Girard, Xavier. "Jean-Charles Blais: la peinture en fuite." *Art Press* 70 (May 1983), 36–37.
Haenlein, Carl, ed. *Jean-Charles Blais*. Exh. cat., Kestner-Gesellschaft. Hanover, 1986.
Jean-Charles Blais/Gérard Garouste: Peintures et dessins. Exh. cat., Musée d'art contemporain de Montréal. Montréal, 1986. With essay by Johanne Lamoureux.

Mel Bochner

Born:
Pittsburgh, Pennsylvania, 1940

Lives:
New York, New York

Education:
Carnegie Institute of Technology, Pittsburgh, Pennsylvania, B.F.A., 1962.

Bibliography:
Cummings, Paul. "Interview: Mel Bochner Talks with Paul Cummings." *Drawing* 10 (May–June 1988): 9–13.
Marano, Lizbeth. *Parasol and Simca: Two Presses/Two Processes*. Exh. cat., The Center Gallery of Bucknell University. Lewisburg, Pennsylvania, 1984.
"Mel Bochner: Abstraction Up Against the Wall." *View: The Photojournal of Art* (April 1989): 54–57.
Mel Bochner Drawings. Exh. cat., David Nolan Gallery. New York, 1988.
Mel Bochner: 1973–1985. Exh. cat., Carnegie-Mellon University Art Gallery. Pittsburgh, 1985. With an essay by Elaine A. King and an interview with the artist by Charles Stuckey.

Lorenzo Bonechi

Born:
Figline Valdarno, Italy, 1955

Lives:
Figline Valdarno, Italy

Education:
Accademia di Belle Arti e Liceo Artistico, Florence, Italy, 1969–1976.

Bibliography:
Fox, Howard N. *A New Romanticism: Sixteen Artists from Italy*. Exh. cat., Hirshhorn Museum and Sculpture Garden. Washington, 1985.

Heartney, Eleanor. "Lorenzo Bonechi." *ARTnews* 85 (February 1986): 124.

Jacobowitz, Ellen S., and Ann Percy. *New Art on Paper.* Exh. cat., Philadelphia Museum of Art. Philadelphia, 1988: 20–21, 59.

Lorenzo Bonechi. Exh. cat., Galleria Carini. Florence, 1985. With an essay by Carl Brandon Strehlke.

Yau, John. "Lorenzo Bonechi." *Artforum* 24 (March 1986): 122–23.

Jonathan Borofsky

Born:
Boston, Massachusetts, 1942

Lives:
Topanga Canyon, California

Education:
Carnegie Institute of Technology , Pittsburgh, Pennsylvania, B.F.A., 1964.
Écoles d'Art Americaines de Fontainebleau, Fontainebleau, France, 1964.
Yale University, School of Art and Architecture, New Haven, Connecticut, M.F.A., 1966.

Bibliography:

Borofsky, Jonathan. "Dreams." *The Paris Review* 23 (Winter 1981): 89–101.

Fine, Ruth E. *Gemini G.E.L.: Art and Collaboration.* Exh. cat., National Gallery of Art. Washington, 1984: 50–53, 161–77, 245–49, 253.

Klein, Michael. "Jonathan Borofsky: Private & Public." *The Print Collector's Newsletter* 14 (May–June 1983): 51, 54.

Marshall, Richard, and Mark Rosenthal. *Jonathan Borofsky.* Exh. cat., Philadelphia Museum of Art. Philadelphia, 1984.

Volmer, Suzanne. "Drawings and Prints: As the Twain Meet." *Arts Magazine* 57 (February 1983): 84–85.

Richard Bosman

Born:
Madras, India, 1944

Lives:
New York, New York

Education:
Byam Shaw School of Art, London, England, 1964–1969.
New York Studio School of Drawing, Painting and Sculpture, New York, 1969–1971.
Skowhegan School of Painting and Sculpture, Skowhegan, Maine, 1970.

Bibliography:

Armstrong, Elizabeth, and Marge Goldwater. *Images and Impressions: Painters Who Print.* Exh. cat., Walker Art Center. Minneapolis, 1984: 10–15.

Phillips, Deborah C. "Richard Bosman." *Arts Magazine* 55 (January 1981): 13.

Siegel, Jeanne. "Richard Bosman: Stories of Violence." *Arts Magazine* 57 (April 1983): 126–28.

Soldaini, Antonella. "Richard Bosman." *Flash Art* 125 (December 1985–January 1986), 36–37.

Stevens, Andrew. *Prints by Richard Bosman.* Exh. cat., Elvehjem Museum of Art, University of Wisconsin. Madison, 1989.

Chris Burden

Born:
Boston, Massachusetts, 1946

Lives:
Topanga Canyon, California

Education:
Pomona College, Claremont, California, B.A., 1969.
University of California, Irvine, California, M.F.A., 1971.

Bibliography:

Cebulski, Frank. "Sculptors As Printmakers." *Artweek* 13 (August 28, 1982): 16.

Gambrell, Jamey. "All the News That's Fit for Prints: A Parallel of Social Concerns of the 1930s & 1980s." *The Print Collector's Newsletter* 18 (May–June 1987): 54.

Pagel, David. "Chris Burden." *Artscribe* 72 (November–December 1988): 85.

Selwyn, Marc. "Chris Burden." *Flash Art* 144 (January–February 1989): 90–94.

Wye, Deborah. *Committed To Print: Social and Political Themes in Recent American Printed Art.* Exh. cat., The Museum of Modern Art. New York, 1988: 60, 102.

Steven Campbell

Born:
Glasgow, Scotland, 1953

Lives:
Glasgow, Scotland

Education:
Glasgow School of Art, Glasgow, Scotland, 1978–1982.

Bibliography:

Morgan, Stuart. "Soup's On: An audience with Steven Campbell." *Artscribe* 48 (September–October 1984): 30–35.

Steven Campbell: New Paintings. Exh. cat., Riverside Studios. London, 1984. With an essay by Stuart Morgan.

Steven Campbell: Recent Paintings. Exh. cat., Marlborough Fine Art, Ltd. London, 1987. With an essay by Tony Godfrey.

Steven Campbell: Recent Work. Exh. cat., Marlborough Gallery, Inc. New York, 1988. With an essay by Andrew Wilson.

Viewpoints: Steven Campbell. Exh. brochure, Walker Art Center. Minneapolis, 1985. With an essay by Marge Goldwater.

Sauro Cardinali

Born:
Spina, Italy, 1951

Lives:
Perugia and Rome, Italy

Education:
Accademia di Belle Arti, Carrara, Italy, 1976–1980.

Bibliography:

Sauro Cardinali. Exh. cat., Rocca Paolina, City of Perugia. Perugia, 1985. With an essay by Giorgio Bonomi.

Vija Celmins

Born:
Riga, Latvia, 1939

Lives:
New York, New York

Education:
Herron School of Art, Indianapolis, Indiana, B.F.A., 1962.
University of California, Los Angeles, Los Angeles, California, M.F.A., 1965.

Bibliography:
Armstrong, Richard. "Of Earthly Objects and Stellar Sights: Vija Celmins." *Art in America* 69 (May 1981): 101–07.
Field, Richard S., and Ruth E. Fine. *A Graphic Muse: Prints by Contemporary American Women.* Exh. cat., Mount Holyoke College Art Museum. New York and South Hadley, Massachusetts, 1987: 59–63.
Fine, Ruth E. *Gemini G.E.L.: Art and Collaboration.* Exh. cat., National Gallery of Art. Washington, 1984: 11, 30, 209, 240–41, 254.
Ratcliff, Carter. "Vija Celmins: An Art of Reclamation." *The Print Collector's Newsletter* 14 (January–February 1984): 193–196.
Vija Celmins: A Survey Exhibition. Exh. cat., Newport Harbor Art Museum. Newport Beach, California, 1979. With an essay by Susan C. Larsen.

Louisa Chase

Born:
Panama City, Panama, 1951

Lives:
New York, New York

Education:
Yale University School of Art, Norfolk, Connecticut, 1971.
Syracuse University, Syracuse, New York, B.F.A., 1973.
Yale University, School of Art and Architecture, New Haven, Connecticut, M.F.A., 1975.

Bibliography:
Armstrong, Elizabeth, and Marge Goldwater. *Images and Impressions: Painters Who Print.* Exh. cat., Walker Art Center. Minneapolis, 1984: 16–20.
Field, Richard S., and Ruth E. Fine. *A Graphic Muse: Prints by Contemporary American Women.* Exh. cat., Mount Holyoke College Art Museum. New York and South Hadley, Massachusetts, 1987: 64–67.
Louisa Chase. Exh. cat., Robert Miller Gallery. New York, 1984. With text from the artist's diary.
Peters, Lisa Nicol. "Louisa Chase." *Arts Magazine* 57 (November 1982): 8.
Woodville, Louisa. "Louisa Chase." *Arts Magazine* 58 (June 1984): 11.

Sandro Chia

Born:
Florence, Italy, 1946

Lives:
Montalcino, Italy and Rhinebeck, New York

Education:
Accademia di Belle Arti e Liceo Artistico, Florence, Italy, 1969.

Bibliography:
Berger, Danny. "Sandro Chia in His Studio: An Interview." *The Print Collector's Newsletter* 12 (January–February 1982): 168–69.
Fox, Howard N. *A New Romanticism: Sixteen Artists from Italy.* Exh. cat., Hirshhorn Museum and Sculpture Garden. Washington, 1985: 50–53, 103–05.
Sandro Chia. Exh. cat., Stedelijk Museum. Amsterdam, 1983. With an exchange of letters between Edy de Wilde and the artist and an essay by Alexander van Gravenstein.
Sandro Chia: Bilder, 1976–1983. Exh. cat., Kestner-Gesellschaft. Hanover, 1983. With essays by Henry Geldzahler, Carl Haenlein, and Anne Seymour.
Sandro Chia Prints 1973–1984: An Exhibition and Sale. Exh. cat., The Mezzanine Gallery, The Metropolitan Museum of Art. New York, 1984.

Francesco Clemente

Born:
Naples, Italy, 1952

Lives:
Rome, Italy; Madras, India; New York, New York

Bibliography:
Armstrong, Elizabeth, and Marge Goldwater. *Images and Impressions: Painters Who Print.* Exh. cat., Walker Art Center. Minneapolis, 1984: 22–27.
Auping, Michael. *Francesco Clemente.* Exh. cat., The John and Mable Ringling Museum of Art. Sarasota, 1985.
Berger, Danny. "Francesco Clemente at the Metropolitan: An Interview." *The Print Collector's Newsletter* 13 (March–April 1982): 11–13.
Haenlein, Carl. *Francesco Clemente: Bilder und Skulpturen.* Exh. cat., Kestner-Gesellschaft. Hanover, 1984.
White, Robin. "Francesco Clemente" (an interview with the artist). *View* 3 (November 1981). Published by Crown Point Press, Oakland.

Gregory Crane

Born:
Bremerton, Washington, 1951

Lives:
Brooklyn, New York

Education:
University of Utah, Salt Lake City, Utah, B.F.A., 1975.
Art Students League of New York, New York, 1976–1980.

Bibliography:
Clay, Willy. "Gregory Crane." *Arts Magazine* 59 (December 1984): 7.
Cohrs, Timothy. "Hudson River Editions, Pelavin Editions—A Report Back from the Other-World of Printmaking." *Arts Magazine* 61 (November 1986): 41–43.
Little, Carl. "Gregory Crane at Edward Thorp." *Art in America* 76 (November 1988): 177.
Mahoney, Robert. "Galleries: Regional Paradise." *New York Press* (20 May 1988): 33.
McGuigan, Cathleen. "Transforming the Landscape." *Newsweek* (26 December 1988): 60–62.

Susan Crile

Born:
Cleveland, Ohio, 1942

Lives:
New York, New York

Education:
Bennington College, Bennington, Vermont, B.A., 1965.
New York University, New York, New York, 1962–1964.
Hunter College, New York, New York, 1971–1972.

Bibliography:
Field, Richard S., and Ruth E. Fine. *A Graphic Muse: Prints by Contemporary American Women*. Exh. cat., Mount Holyoke College Art Museum. New York and South Hadley, Massachusetts, 1987: 68–72.
Frank, Elizabeth. *Susan Crile: Recent Paintings*. Exh. cat., Cleveland Center for Contemporary Art. Cleveland, 1984.
Langer, Sandra. *Susan Crile: Recent Paintings*. Exh. cat., Graham Modern. New York, 1985.
Walker, Barry. *The American Artist as Printmaker: 23rd National Print Exhibition*. Exh. cat., The Brooklyn Museum. Brooklyn, 1983: 49.
Westfall, Stephen. "Susan Crile at Graham Modern." *Art in America* 73 (July 1985): 131.

Enzo Cucchi

Born:
Morro d'Alba, Italy, 1950

Lives:
Ancona and Rome, Italy

Bibliography:
Faber, Monika. "Über Francesco Clemente und Enzo Cucchi." In *Druckgraphik 1970–85*, edited by Peter Pakesch. Exh. cat., Künstlerhaus Graz, Grazer Kunstverein. Graz, Austria, 1986: 87–90.
Berger, Danny. "Enzo Cucchi: An Interview." *The Print Collector's Newsletter* 13 (September–October 1982): 118–20.
"Enzo Cucchi: A Conversation with Paola Igliori." *Artscribe* 57 (April–May 1986): 56–57.
Peter Blum Edition New York II. Exh. cat., Groninger Museum. Groningen, Netherlands, 1985: 8–9, 16–19. With an essay by Steven Kolsteren.
Poirier, Maurice. "Enzo Cucchi: Solomon R. Guggenheim Museum." *ARTnews* 85 (September 1986): 126.

Walter Dahn

Born:
St. Tönis bei Krefeld, Federal Republic of Germany, 1954

Lives:
Cologne, Federal Republic of Germany

Education:
Kunstakademie Düsseldorf, Düsseldorf, Federal Republic of Germany, 1971–1977.

Bibliography:
Dickhoff, Wilfried. "A Bootful of Brains: The Soulful Image of Walter Dahn." *Artscribe* 57 (April–May 1986): 40–43.
Dickhoff, Wilfried. *Walter Dahn: Gemälde 1981–1985*. Exh. cat., Kunsthalle Basel. Basel, 1986.

Walter Dahn: Peintures 1986. Exh. cat., Musée de Grenoble. Grenoble, 1986. With an introduction by Jean-Paul Monery and a poem by A. R. Penck.
Walter Dahn: Probedrucke zu den Siebdruckbildern 1985. Exh. cat., Galerie Six Friedrich. Munich, 1986.
Walter Dahn: Zeichnungen 1972–1985, 12 Skulpturen 1984–1985. Exh. cat., Museum für Gegenwartskunst. Basel, 1986. With an interview of the artist by Dieter Koepplin.

Martha Diamond

Born:
New York, New York, 1944

Lives:
New York, New York

Education:
Art Students League of New York, New York, 1962.
Carleton College, Northfield, Minnesota, B.A., 1964.
Alliance Française, Paris, France, 1965.
New York University, New York, New York, M.A., 1969.

Bibliography:
Armstrong, Richard, et. al. *1989 Biennial Exhibition*. Exh. cat., Whitney Museum of American Art. New York, 1989: 44–47.
Coffey, John W. *Martha Diamond*. Exh. cat., Bowdoin College Museum of Art. Brunswick, Maine, 1988.
Martha Diamond. Exh. cat., Robert Miller Gallery. New York, 1988. With an essay by Stephen Westfall.
"Martha Diamond, Monotypes, 1982–84." *The Print Collector's Newsletter* 15 (May–June 1984): 59–60.
Westfall, Stephen. "Martha Diamond." *Arts Magazine* 60 (September 1985): 41–42.

Jane Dickson

Born:
Chicago, Illinois, 1952

Lives:
New York, New York

Education:
School of the Museum of Fine Arts, Boston, Massachusetts, Studio Diploma, 1976.
Harvard University, Cambridge, Massachusetts, B.F.A., 1976.

Bibliography:
Bass, Ruth. "New Editions: Jane Dickson." *ARTnews* 84 (October 1985): 96.
Field, Richard S., and Ruth E. Fine. *A Graphic Muse: Prints by Contemporary American Women*. Exh. cat., Mount Holyoke College Art Museum. New York and South Hadley, Massachusetts, 1987: 73–75.
Gould, Claudia. "Jane Dickson: An Interview." *The Print Collector's Newsletter* 17 (January–February 1987): 204–06.
Jane Dickson: Drawings. Exh. brochure, Fawbush Gallery. New York, 1988. With an introduction by Robert McDaniel.
Nadelman, Cynthia. "Artists the Critics are Watching: Jane Dickson." *ARTnews* 83 (November 1984): 76–78.

Richard Diebenkorn

Born:
Portland, Oregon, 1922

Lives:
Venice, California

Education:
University of California, Berkeley, California, 1943.
California School of Fine Arts, San Francisco, California, 1946.
Stanford University, Palo Alto, California, B.A., 1949.
University of New Mexico, Albuquerque, New Mexico, M.F.A., 1952.

Bibliography:
Buck, Robert T., Jr., Linda L. Cathcart, Gerald Nordland, and Maurice Tuchman. *Richard Diebenkorn: Paintings and Drawings, 1943–1980.* Exh. cat., Albright-Knox Art Gallery. Buffalo, 1980.
Jan Butterfield. Interview with Richard Diebenkorn. In *Pentimenti: Seeing and then Seeing Again.* Brochure published in conjunction with the brochure accompanying the exhibition *Richard Diebenkorn: Paintings 1948–1983* by the San Francisco Museum of Modern Art. San Francisco, 1983.
Fine, Ruth E. *Gemini G.E.L.: Art and Collaboration.* Exh. cat., National Gallery of Art. Washington, 1984: 230–31, 255–56.
Gruen, John. "Richard Diebenkorn: The Idea is to Get Everything Right." *ARTnews* 85 (November 1986): 80–87.
Stevens, Mark. *Richard Diebenkorn: Etchings and Drypoints 1949–1980.* Exh. cat., The Minneapolis Institute of Arts, and traveling. Houston: Houston Fine Art Press, 1981.

Jiri Georg Dokoupil

Born:
Bruntál, Czechoslovakia, 1954

Lives:
New York, New York; Cologne, Federal Republic of Germany; and Tenerife, Canary Islands

Bibliography:
Delano Greenidge Editions. *Projects and Editions 1984–1987.* New York, 1987.
Dokoupil: Arbeiten/Travaux/Works, 1981–1984. Exh. cat., Museum Folkwang. Essen, 1984.
Fox, Howard N. *Avant-Garde in the Eighties.* Exh. cat., Los Angeles County Museum of Art. Los Angeles, 1987: 96–97, 155.
Iannacci, Anthony. "Jiri Georg Dokoupil." *Artscribe* 67 (January–February 1988): 74–75.
Kuspit, Donald. "Jiri Georg Dokoupil." *Artforum* 25 (March 1987): 121–22.

Felix Droese

Born:
Singen/Hohentwiel, Federal Republic of Germany, 1950

Lives:
Düsseldorf, Federal Republic of Germany; Paesens, Netherlands

Education:
Kunstakademie, Düsseldorf, 1970.

Bibliography:
Ackley, Clifford S., Thomas Krens, and Deborah Menaker. *The Modern Art of the Print: Selections from the Collection of Lois and Michael Torf.* Exh. cat., Williams College Museum of Art. Williamstown, Massachusetts, 1984: 130–31.
Bardon, Annie. "New Paths in Germany: the Woodcuts of Droese, Kluge & Mansen." *The Print Collector's Newsletter* 17 (November–December 1986): 157–62.
Felix Droese Abdruck: Skulpturen und Drucke 1984–1986. Exh. cat., Produzentengalerie. Hamburg, 1987.
Felix Droese: Drucke vom Holz. Exh. cat., Rathaus Reutlingen. Reutlingen, 1985.
Mangelmutanten überleben Kapitalismus: Bleistiftzeichnungen von Felix Droese. Exh. cat., Museum Hans Lange. Krefeld, 1984.

Carroll Dunham

Born:
New Haven, Connecticut, 1949

Lives:
New York, New York

Education:
Trinity College, Hartford, Connecticut, B.A., 1971.

Bibliography:
Armstrong, Elizabeth, and Sheila McGuire. *First Impressions: Early Prints by Forty-six Contemporary Artists.* Exh. cat., Walker Art Center. Minneapolis, 1989: 134–35.
Columbo, Paolo. *Carroll Dunham: Selected Drawings.* Exh. brochure, Tyler Gallery, Temple University. Elkins Park, Pennsylvania, 1988.
Kertess, Klaus. "Carroll Dunham: Painting Against The Grain—Painting With The Grain." *Artforum* 21 (Summer 1983): 53–54.
Perl, Jed. "Retro Madness." *The New Criterion* 5 (October 1986): 67–70.
Salz, Jerry. "Carroll Dunham's Untitled (1987)." *Arts Magazine* 62 (January 1988): 58–59.

Aaron Fink

Born:
Boston, Massachusetts, 1955

Lives:
Boston, Massachusetts

Education:
Skowhegan School of Painting and Sculpture, Skowhegan, Maine, 1976.
Maryland Institute, College of Art, Baltimore, Maryland, B.F.A., 1977.
Yale University, School of Art and Architecture, New Haven, Connecticut, M.F.A., 1979.

Bibliography:
Bonetti, David. "On and off the street." *The Boston Phoenix* (24 April 1987).
Halbreich, Kathy. *Aaron Fink.* Exh. cat., Hartje Gallery. Frankfurt am Main, 1986.
Tarlow, Lois. "Aaron Fink." *Art New England* 10 (March 1989): 8–9.
Temin, Christine. "Images like clues in a mystery." *The Boston Globe* (23 April 1987).
Walker, Barry. *The American Artist as Printmaker: 23rd National Print Exhibition.* Exh. cat., The Brooklyn Museum. Brooklyn, 1983: 57.

Eric Fischl

Born:
New York, New York, 1948

Lives:
New York, New York

Education:
California Institute of the Arts, Valencia, California, B.F.A., 1972.

Bibliography:
Ackley, Clifford S., Thomas Krens, and Deborah Menaker. *The Modern Art of the Print: Selections from the Collection of Lois and Michael Torf.* Exh. cat., Williams College Museum of Art. Williamstown, Massachusetts, 1984: 112–13.

Baker, Kenneth. "Eric Fischl: 'Year of the Drowned Dog.'" *The Print Collector's Newsletter* 15 (July–August 1984): 81–84.

Glenn, Constance W., and Lucinda Barnes. *Eric Fischl: Scenes Before the Eye.* Exh. cat., University Art Museum, California State University, Long Beach. Long Beach, 1986.

Grimes, Nancy. "Eric Fischl's Naked Truths." *ARTnews* 85 (September 1986): 70–78.

Lewallen, Constance, and Tazmi Shinoda. "Eric Fischl" (an interview with the artist). *View* 5 (Fall 1988). Published by Crown Point Press, San Francisco.

Mary Frank

Born:
London, England, 1933

Lives:
New York, New York and Lake Hill, New York

Education:
Studied with Max Beckmann, 1950, and Hans Hoffmann, 1951.

Bibliography:
Mary Frank: Sculpture and Works on Paper. Exh. cat., Zabriskie Gallery. New York, 1986.

Moore, John McDonald. "The Drawings of Mary Frank." *Drawing* 7 (January–February 1986): 97–101.

Moorman, Margaret. "In A Timeless World." *ARTnews* 86 (May 1987): 90–98.

Ratcliff, Carter. "Mary Frank's Monotypes." *The Print Collector's Newsletter* 9 (November–December 1978): 151–154.

Walker, Barry. "The Single State." *ARTnews* 83 (March 1984): 60–65.

Glenn Goldberg

Born:
Bronx, New York, 1953

Lives:
New York, New York

Education:
New York Studio School of Drawing, Painting and Sculpture, New York, 1977–1978.

Queens College, City University of New York, Flushing, New York, B.A., 1976; M.F.A., 1980.

Bibliography:
Cohen, Ronny H. "New Abstraction V." *The Print Collector's Newsletter* 18 (March–April 1987): 11–12.

Heartney, Eleanor. "Glenn Goldberg at Willard." *Art in America* 75 (September 1987): 174–75.

April Gornik

Born:
Cleveland, Ohio, 1953

Lives:
New York, New York

Education:
Cleveland Institute of Art, Cleveland, Ohio, 1971–1975.
Nova Scotia College of Art and Design, Halifax, Nova Scotia, Canada, B.F.A., 1976.

Bibliography:
Cohrs, Timothy. "Hudson River Editions, Pelavin Editions—A Report Back from the Other-World of Printmaking." *Arts Magazine* 61 (November 1986): 41–43.

Heartney, Eleanor. "April Gornik's Stormy Weather." *ARTnews* 88 (May 1989): 120–25.

Lewallen, Constance. "April Gornik" (an interview with the artist). *View* 5 (Fall 1988). Published by Crown Point Press, San Francisco.

McGuigan, Cathleen. "Transforming the Landscape." *Newsweek* (26 December 1988): 60–62.

West, Harvey. *Sources of Light: Contemporary American Luminism.* Exh. cat., Henry Art Gallery, University of Washington, Seattle. Seattle, 1985: 34–39.

Philip Guston

Born:
Montréal, Canada, 1913

Died:
Woodstock, New York, 1980

Education:
Otis Art Institute of Los Angeles County, Los Angeles, California, 1930.

Bibliography:
Elderfield, John. *Philip Guston: A Drawing Retrospective.* Exh. cat., The Museum of Modern Art. New York, 1988.

Fine, Ruth E. *Gemini G.E.L.: Art and Collaboration.* Exh. cat., National Gallery of Art. Washington, 1984: 102–3, 257–58.

Mayer, Musa. *Night Studio.* New York: Alfred A. Knopf, 1988.

Philip Guston, 3 vols. Los Angeles: Gemini G.E.L. 1980, 1981, 1983. With an essay by John Coplans in vol. 1.

Philip Guston. Exh. cat., San Francisco Museum of Modern Art. San Francisco, 1980.

Michael Hafftka

Born:
New York, New York, 1953

Lives:
Brooklyn, New York

Bibliography:
Hunter, Sam. *Michael Hafftka: New Paintings.* Exh. cat., DiLaurenti Gallery Ltd. New York, 1987.

Brodsky, Michael. *Michael Hafftka: Selected Drawings 1975–81.* Tivoli, New York: Guignol Books, 1981.

King, Elaine A., and John Caldwell. *Michael Hafftka: Paintings 1983–1984.* Exh. cat., Hewlett Gallery, Carnegie-Mellon University. Pittsburgh, 1984.

Walker, Barry. *Public and Private: American Prints Today; The 24th National Print Exhibition.* Exh. cat., The Brooklyn Museum. Brooklyn, 1986: 71.

Michael Heindorff

Born:
Brunswick, Federal Republic of Germany, 1949

Lives:
London, England

Education:
Hochschule für Bildende Künste Braunschweig, Brunswick, Federal
 Republic of Germany, 1970–1974.
Royal College of Art, London, England, 1975–1977.

Bibliography:
Jacobson, Bernard. *Michael Heindorff: Tasso's Trees*. Exh. cat., Bernard
 Jacobson Gallery. London and New York, 1986.
Michael R. Klein. "Michael Heindorff." *Arts Magazine* 53 (March
 1979): 20.
Beaumont, Mary Rose. "Michael Heindorff." *Arts Review* 39 (23 October
 1987): 719.
Turner, Francia. "Contemporary Print-making: Old Means and New (The
 work of Kelpra, Mara, Heindorff)." *The Oxford Art Journal* 6 (1983):
 30–38.

Al Held

Born:
New York, New York, 1928

Lives:
New York, New York

Education:
Art Students League of New York, New York, 1948–1949.
Académie de la Grande Chaumière, Paris, France, 1950–1953.

Bibliography:
Al Held: New Paintings. Exh. cat., Donald Morris Gallery, Inc. Birming-
 ham, Michigan, 1988.
Al Held: Watercolors. Exh. cat., Andre Emmerich Gallery. New York,
 1988. With an essay by Andrew Forge.
Glaser, David J. "Al Held's Strategy of Structural Conflict." *Arts Magazine*
 57 (January 1983): 82–83.
Lewallen, Constance. "Al Held" (an interview with the artist). *View* 6
 (Winter 1989). Published by Crown Point Press, San Francisco.
Sandler, Irving. *Al Held*. New York: Hudson Hills Press, 1984.

Roger Herman

Born:
Saarbrücken, Federal Republic of Germany, 1947

Lives:
Los Angeles, California

Education:
Universität des Saarlandes, Saarbrücken, Federal Republic of Germany,
 1969–1972.
Staatliche Akademie der Bildenden Künste, Karlsruhe, Federal Republic
 of Germany, 1972–1976.

Bibliography:
Armstrong, Elizabeth, and Marge Goldwater. *Images and Impressions:
 Painters Who Print*. Exh. cat., Walker Art Center. Minneapolis, 1984:
 28–33.
Brody, Jacqueline. "Roger Herman: A New Expressionist?" *The Print Col-
 lector's Newsletter* 6 (January–February 1985): 200–05.

Liss, Andrea. "A Romantic Conflict." *Artweek* 16 (11 May 1985): 3.
Mallinson, Constance. "Roger Herman at Larry Gagosian." *Art in Amer-
 ica* 73 (December 1985): 135.
Selz, Peter. "Roger Herman." *Arts Magazine* 58 (December 1983): 12.

Franz Hitzler

Born:
Thalmässing bei Regensburg, Federal Republic of Germany, 1946

Lives:
Munich, Federal Republic of Germany

Education:
Akademie der Bildenden Künste, Munich, Federal Republic of Germany,
 1967–1972.

Bibliography:
Franz Hitzler: Arbeiten auf Papier von 1977 bis 1982. Exh. cat., Städtis-
 ches Museum Leverkusen. Leverkusen, 1982. With an essay by Herbert
 Schneidler.
Franz Hitzler: Bilder 1975–1985. Exh. cat., Staatsgalerie moderner Kunst.
 Munich, 1986. With essays by Carla Schulz-Hoffmann, Peter-Klaus
 Schuster, and Herbert Schneidler.
Kuspit, Donald B. "Painting to Satiety: Franz Hitzler and Troels Wörsel."
 Arts Magazine 57 (February 1983): 86–87.

Antonius Höckelmann

Born:
Oelde, Germany, 1937

Lives:
Cologne, Federal Republic of Germany

Education:
Hochschule für bildende und angewandte Kunst, East Berlin,
 1957–1961.

Bibliography:
Antonius Höckelmann. Exh. cat., Kunstverein in Hamburg. Hamburg,
 1986. With essays by Karl-Egon Vester, Hille Eilers, Günther Gercken,
 Bernhard Kerber, and Martin Hentschel.
Antonius Höckelmann: Skulpturen Handzeichnungen. Exh. cat., Josef-
 Haubrich-Kunsthalle. Cologne, 1980. With essays by Wolfgang
 Kahlcke and Siegfried Gohr.
Dückers, Alexander. *Erste Konzentration*. Munich: Maximilian Verlag-
 Sabine Knust, 1982.
Kuspit, Donald B. "Antonius Höckelmann at Alfred Kren." *Art in America*
 73 (December 1985): 126.

Howard Hodgkin

Born:
London, England, 1932

Lives:
London and Wiltshire, England

Education:
Camberwell School of Art and Crafts, London, England, 1949–1950.
Bath Academy of Art, Corsham, England, 1950–1954.

Bibliography:
Dunham, Judith. "Howard Hodgkin's Accumulated Memories." *Print
 News* 8 (Winter 1986): 4–7.
Gilmour, Pat. "Howard Hodgkin." *The Print Collector's Newsletter* 12
 (March–April 1981): 1–5.
Howard Hodgkin: Opera grafica 1977–1983. Exh. cat., British Pavilion,
 Venice Biennale. Venice, 1984.

Howard Hodgkin: Forty Paintings 1973–84. Exh. cat., The Whitechapel Art Gallery. London, 1984. With an essay by John McEwen and an interview with the artist by David Sylvester.

Howard Hodgkin's Prints 1977 to 1983. Exh. cat. Tate Gallery. London, 1985. With an essay by Richard Morphet.

Jörg Immendorff

Born:
Bleckede, Germany, 1945

Lives:
Düsseldorf, Federal Republic of Germany

Education:
Kunstakademie Düsseldorf, Düsseldorf, Federal Republic of Germany, 1963–1966.

Bibliography:
Armstrong, Elizabeth, and Marge Goldwater. *Images and Impressions: Painters Who Print*. Exh. cat., Walker Art Center. Minneapolis, 1984: 34–39.

Immendorff. Exh. cat., Kunsthaus Zürich. Zürich, 1983. With essays by Harald Szeemann, Toni Stooss, Jörg Huber, Johannes Gachnang, and Siegfried Gohr.

Jörg Immendorff: "Café Deutschland, Adlerhälfte". Exh. cat., Kunsthalle, Düsseldorf. Düsseldorf, 1982. With essays by Jürgen Harten and Ulrich Krempel.

Jörg Immendorff: Café Deutschland Gut, Linolschnitte 82/83. Exh. cat., Wolfgang Wittrock-Kunsthandel. Düsseldorf, 1983.

Jörg Immendorff in Auckland. Exh. cat., Auckland City Art Gallery. Auckland, New Zealand, 1988. With an essay by Andrew Bagle.

Yvonne Jacquette

Born:
Pittsburgh, Pennsylvania, 1934

Lives:
New York, New York, and Searsmont, Maine

Education:
Rhode Island School of Design, Providence, Rhode Island, 1952–1956.

Bibliography:
Beem, Edgar Allen. "A View from Above: Yvonne Jacquette Uses Her Unusual Perspective To Go Beyond Reality." *Maine Times* (25 July 1986): 24–26.

Field, Richard S., and Ruth E. Fine. *A Graphic Muse: Prints by Contemporary American Women*. Exh. cat., Mount Holyoke College Art Museum. New York and South Hadley, Massachusetts, 1987: 96–99.

Horsfield, Kate. "On Art and Artists: Yvonne Jacquette" (an interview with the artist). *Profile* 2 (November 1982). Published by the Video Data Bank, School of the Art Institute of Chicago.

Ratcliff, Carter. "Yvonne Jacquette: American Visionary." *The Print Collector's Newsletter* 12 (July–August 1981): 65–68.

Yvonne Jacquette: Paintings, Monotypes & Drawings. Exh. cat., Brooke Alexander, Inc. New York, 1976. With an essay by Carter Ratcliff.

Bill Jensen

Born:
Minneapolis, Minnesota, 1945

Lives:
New York, New York

Education:
University of Minnesota, Minneapolis, Minnesota, B.F.A., 1968; M.F.A., 1970.

Bibliography:
Bill Jensen. Exh. brochure, Washburn Gallery. New York, 1986. With an essay by Hilton Kramer.

Rathbone, Eliza E. *Bill Jensen*. Exh. cat., The Phillips Collection. Washington, 1987.

Westfall, Stephen. "Into the Vortex." *Art in America* 76 (April 1988): 183–87.

Wye, Deborah. *Bill Jensen: First Etchings*. Exh. cat., The Museum of Modern Art. New York, 1986.

Yau, John. "Alone in a Pitiless Landscape." *Contemporanea* 2 (June 1989): 81–83.

Jasper Johns

Born:
Augusta, Georgia, 1930

Lives:
New York and Stony Point, New York; and St. Martin, West Indies

Education:
University of South Carolina, Columbia, South Carolina, 1947–1948.

Bibliography:
Castleman, Riva. *Jasper Johns: A Print Retrospective*. Exh. cat., The Museum of Modern Art. New York, 1986.

Field, Richard S. *Jasper Johns: Prints 1960–1970*. Exh. cat., Philadelphia Museum of Art. Philadelphia, 1970.

_____. *Jasper Johns: Prints 1970–1977*. Exh. cat., Center for the Arts, Wesleyan University. Middletown, Connecticut, 1978.

Foirades/Fizzles: Echo and Allusion in the Art of Jasper Johns. Exh. cat., Grunwald Center for the Graphic Arts, Wight Art Gallery, University of California, Los Angeles. Los Angeles, 1987. With essays by Andrew Bush, John Cage, James Cuno, Richard S. Field, Fred Orton, and Richard Schiff.

Goldman, Judith. *Jasper Johns: Prints 1977–1981*. Exh. cat., Thomas Segal Gallery. Boston, 1981.

Dennis Kardon

Born:
Des Moines, Iowa, 1950

Lives:
New York, New York

Education:
Yale University, New Haven, Connecticut, B.A., 1973.
Whitney Museum of American Art, Independent Study Program, New York, New York, 1973.

Bibliography:
Butler, Charles T., and Marilyn Laufer. *Recent Graphics from American Print Shops*. Exh. cat., Mitchell Museum. Mount Vernon, Illinois, 1986: 4, 20, 35.

Kardon, Dennis. "A Pained Expression." *Art-Rite* 9 (Spring 1975): 12–13.

Meyer, Jon. "Works on Paper." *Arts Magazine* 57 (May 1983): 9.

Walker, Barry. *The Combination Print: 1980s*. Exh. cat., New Jersey Center for Visual Arts. Summit, New Jersey, 1988: 7, 11.

_____. *Public and Private: American Prints Today; the 24th National Print Exhibition*. Exh. cat., The Brooklyn Museum. Brooklyn, 1986: 81.

Alex Katz

Born:
New York, New York, 1927

Lives:
New York, New York

Education:
Cooper Union for the Advancement of Science and Art, New York, New York, 1946–1949.
Skowhegan School of Painting and Sculpture, Skowhegan, Maine, 1949–1950.

Bibliography:
Beattie, Ann. *Alex Katz*. New York: Harry N. Abrams & Co., 1987.
Field, Richard S. *Alex Katz*. Exh. cat., Davison Art Center, Wesleyan University. Middletown, Connecticut, 1974.
Marshall, Richard. *Alex Katz*. Exh. cat., Whitney Museum of American Art. New York, 1986.
Sandler, Irving. *Alex Katz*. New York: Harry N. Abrams, Inc., Publishers, 1979.
Walker, Barry. *Alex Katz: A Print Retrospective*. Exh. cat., The Brooklyn Museum. Brooklyn, 1987.

Ellsworth Kelly

Born:
Newburgh, New York, 1923

Lives:
Chatham, New York

Education:
Pratt Institute, School of Art and Design, Brooklyn, New York, 1941–1942.
School of the Museum of Fine Arts, Boston, Massachusetts, 1946–1948.
École des Beaux-Arts, Paris, 1948–1949.

Bibliography:
Axsom, Richard H. *The Prints of Ellsworth Kelly: A Catalogue Raisonné, 1949–1985*. New York: Hudson Hills Press, 1987.
Fine, Ruth E. *Gemini G.E.L.: Art and Collaboration*. Exh. cat., National Gallery of Art. Washington, 1984: 126–43.
Rose, Barbara. *Ellsworth Kelly: The Focussed Vision*. Exh. cat., Stedelijk Museum. Amsterdam, 1980.
Tyler Graphics: The Extended Image. Minneapolis: Walker Art Center; New York: Abbeville Press Publishers, 1987. See especially Robert M. Murdock, "Variations on Geometry," 89–119; Ruth E. Fine, "Paperworks at Tyler Graphics," 203–39.
Upright, Diane. *Ellsworth Kelly: Works on Paper*. Exh. cat., Fort Worth Art Museum. New York and Fort Worth, 1987.

Per Kirkeby

Born:
Copenhagen, Denmark, 1938

Lives:
Copenhagen, and Taerö Island, Denmark; Frankfurt, Federal Republic of Germany

Education:
University of Copenhagen, Copenhagen, Denmark, 1957.

Bibliography:
Gachnang, Johannes. "Broodthaers / Roth / Johns / Rainer / LeWitt / Kirkeby." In *Druckgraphik 1970–85*, edited by Peter Pakesch. Exh. cat., Künstlerhaus Graz, Grazer Kunstverein. Graz, Austria, 1986: 9–35.
Kirkeby, Per. "Probedrucke." In *Druckgraphik 1970–85*, edited by Peter Pakesch. Exh. cat., Künstlerhaus Graz, Grazer Kunstverein. Graz, Austria, 1986: 36–42.
Lamarche-Vadel, Bernard. "Per Kirkeby du Sol au Paysage." *Art Press* 134 (March 1989): 37–38.
Per Kirkeby. Exh. cat., Kunstverein Braunschweig. Brunswick, 1984.
Zacharopoulos, Denys. "The Desperation of the Nebulae." *Artforum* 27 (February 1989): 107–13.

Gustav Kluge

Born:
Wittenberg, German Democratic Republic, 1947

Lives:
Hamburg, Federal Republic of Germany

Education:
Hochschule für Bildende Künste, Hamburg, Federal Republic of Germany, 1968–1973.

Bibliography:
Bardon, Annie. "New Paths in Germany: the Woodcuts of Droese, Kluge & Mansen." *The Print Collector's Newsletter* 17 (November–December 1986): 157–62.
Gustav Kluge: Holzdrucke. Exh. cat., Spendhaus Reutlingen. Reutlingen, Germany, 1986.
Macoré-Kommentar: Gustav Kluge. Exh. cat., Raum für Kunst. Hamburg, 1986.
Gustav Kluge: Nebenstimmen, Minus-Plus-Fuge, Eindrehung, Zueignungen. Exh. cat., Bonner Kunstverein. Bonn, 1987. With essays by Annielie Pohlen and Karl Egon Vester.

Oleg Kudryashov

Born:
Moscow, U.S.S.R., 1932

Lives:
London, England

Education:
"IZO" (Moscow State Art Studios), Moscow, U.S.S.R., 1942–1947.
School of Fine Arts, Moscow, U.S.S.R., 1950–1951.

Bibliography:
Fisher, Jean. "Oleg Kudryashov." *Artforum* 25 (February 1987): 110–11.
Kalinovska, Milena, and Aidan Dunne. *Oleg Kudryashov*. Exh. cat., Douglas Hyde Gallery, Trinity College. Dublin, 1988.
Oleg Kudryashov: Dry-point Reliefs 1980–1982. Exh. cat., Riverside Studios. London, 1983.
Oleg Kudryashov: Recent Works. Exh. cat., Robert Brown Contemporary Art. Washington, 1984. With an essay by Greg Hilty.
Oleg Kudryashov: Reliefs. Exh. cat., Galerie Patrick Cramer. Geneva, 1988. With excerpts from the artist's "Notes and Reminiscences."

Mark Leithauser

Born:
Detroit, Michigan, 1950

Lives:
Washington, D.C.

Education:
Wayne State University, Detroit, Michigan, B.A., 1972; M.A., 1973; M.F.A., 1976.

Bibliography:
The Etchings of Mark Leithauser. Exh. cat., Hom Gallery. Washington, 1981.
Henry, Gerrit. "Mark Leithauser at Coe Kerr." *Art in America* 76 (July 1988): 138.
Lewis, Jo Ann. "Mark Leithauser, Starting at the Top." *Washington Post* (28 January 1988): D1.
Wilmerding, John, and Ruth E. Fine. *Mark Leithauser: Paintings, Drawings, Prints.* Exh. cat., Coe Kerr Gallery. New York, 1988.

Robert Longo

Born:
Brooklyn, New York, 1953

Lives:
New York, New York

Education:
State University of New York, College at Buffalo, Buffalo, New York, B.F.A., 1975.

Bibliography:
Bonaventura, Paul. "Robert Longo: A Report to the Future." *Artefactum* 6 (January–February 1989): 12–17.
Gardner, Paul. "Longo: Making Art for Brave Eyes." *ARTnews* 84 (May 1985); 56–65.
Hobbs, Robert. *Robert Longo: Dis-Illusions.* Exh. cat., The University of Iowa Museum of Art. Iowa City, 1985.
Ratcliff, Carter. "Robert Longo: The City of Sheer Image." *The Print Collector's Newsletter* 14 (July–August 1983): 95–98.
Ratcliff, Carter. *Robert Longo.* New York: Rizzoli, 1985.

Markus Lüpertz

Born:
Liberec, Czechoslovakia, 1941

Lives:
Karlsruhe and Berlin, Federal Republic of Germany

Education:
Werkkunstschule, Krefeld, Federal Republic of Germany, 1956–1963.
Kunstakademie, Düsseldorf, Federal Republic of Germany, 1963.

Bibliography:
Cowart, Jack. *Expressions: New Art from Germany.* Exh. cat., St. Louis Art Museum. St. Louis, 1983: 124–45.
Dietrich, Dorothea. "A Conversation with Markus Lüpertz." *The Print Collector's Newsletter* 14 (March–April 1983): 9–12.
Gachnang, Johannes, and Siegfried Gohr, eds. *Markus Lüpertz: Zeichnungen aus den Jahren 1964–1982.* Bern and Berlin: Verlag Gachnang & Springer, 1986.

Gercken, Günther. "Renaissance der Druckgraphik: Georg Baselitz, Jörg Immendorff, Markus Lüpertz, A. R. Penck." In *Druckgraphik 1970–1985,* edited by Peter Pakesch. Exh. cat., Künstlerhaus Graz, Grazer Kunstverein. Graz, Austria, 1986: 43–63.
Odermatt, Jean. "Synchroncitation: Markus Lüpertz' 'New York Diary 1984'." *Parkett* 4 (1985): 71–87.

Robert Mangold

Born:
North Tonawanda, New York, 1937

Lives:
Washingtonville, New York

Education:
Cleveland Institute of Art, Cleveland, Ohio, 1956–1959.
Yale University, School of Art and Architecture, New Haven, Connecticut, B.F.A., 1961; M.F.A., 1963.

Bibliography:
Gruen, John. "Robert Mangold, 'A Maker of Images—Nothing More and Nothing Less'." *ARTnews* 86 (Summer 1987): 132–38.
Howard, Jan. *Drawing Now: Robert Mangold.* Exh. cat., The Baltimore Museum of Art. Baltimore, 1987.
Robert Mangold: Gemälde. Exh. cat., Kunsthalle, Bielefeld. Bielefeld, Federal Republic of Germany, 1980. With essays by Heribert Heere and Bernhard Kerber.
Robert Mangold: Schilderijen/Paintings 1964–1982. Exh. cat., Stedelijk Museum. Amsterdam, 1982. With an introduction by Alexander van Grevenstein.
Waldman, Diane. *Robert Mangold.* Exh. cat., The Solomon R. Guggenheim Museum. New York, 1971.

Paul Marcus

Born:
Bronx, New York, 1953

Lives:
New York, New York

Education:
Cooper Union for the Advancement of Science and Art, New York, New York, B.F.A., 1976.
State University of New York, College at Buffalo, New York, M.F.A., 1978.

Bibliography:
Feitlowitz, Marguerite. "Paul Marcus: Prints for the People." *The Print Collector's Newsletter* 16 (September–October 1985): 126–27.
Gambrell, Jamey. "All the News That's Fit for Prints: A Parallel of Social Concerns of the 1930s & 1980s." *The Print Collector's Newsletter* 18 (May–June 1987): 52.
Sofer, Ken. "New Editions." *ARTnews* 86 (October 1987): 133.
Wye, Deborah. *Committed to Print: Social and Political Themes in Recent Art.* Exh. cat., The Museum of Modern Art. New York, 1988: 92, 110.

Brice Marden

Born:
Bronxville, New York, 1938

Lives:
New York, New York

Education:
Florida Southern College, Lakeland, Florida, 1957–1958.
Boston University, Boston, Massachusetts, B.F.A., 1961.
Yale University, School of Art and Architecture, New Haven, Connecticut, M.F.A., 1963.

Bibliography:
Brice Marden: Paintings, Drawings and Prints 1975–1980. Exh. cat., Whitechapel Art Gallery. London, 1981. With essays by Nicholas Serota, Stephen Bann, and Roberta Smith, and selected statements, notes, and an interview with the artist.
Brice Marden: Zeichnungen/Drawings 1964–1978. Exh. cat., Kunstraum München. Munich, 1979. With essays by Hermann Kern and Klaus Kertess.
Storr, Robert. "Brice Marden: Double Vision." *Art in America* 73 (March 1985): 118–25.
White, Robin. "Brice Marden" (an interview with the artist). *View* 3 (June 1980). Published by Crown Point Press, Oakland.
Yau, John. *Brice Marden: Recent Paintings and Drawings.* Exh. cat., Anthony d'Offay Gallery. London, 1988.

Michael Mazur

Born:
New York, New York, 1935

Lives:
Cambridge, Massachusetts

Education:
Amherst College, Amherst, Massachusetts, B.A., 1958.
Yale University, School of Art and Architecture, New Haven, Connecticut, B.F.A., 1959; M.F.A., 1961.

Bibliography:
Michael Mazur. Exh. cat., The Arts Club of Chicago. Chicago, 1985.
Michael Mazur. Exh. cat., Janus Gallery. Los Angeles, 1982. With an essay by Richard Howard.
Michael Mazur Self-Portraits. Exh. cat., Fawbush Gallery. New York, 1986. With an essay by Barry Walker.
Walker, Barry. "The Single State." *ARTnews* 83 (March 1984): 60–62.
_____. *The Combination Print 1980s.* Exh. cat., New Jersey Center for Visual Arts. Summit, New Jersey, 1988: 5, 11, 20.

George McNeil

Born:
New York, New York, 1908

Lives:
Brooklyn, New York

Education:
Pratt Institute, School of Art and Design, Brooklyn, New York, 1927–1929.
Art Students League of New York, New York, 1930–1933.
Studied with Hans Hoffmann, 1933–1936.

Bibliography:
Brenson, Michael. "Expressionism and George McNeil." *New York Times* (5 October 1984).
George McNeil: Abstractscapes and Figures. Exh. cat., University Art Gallery, State University of New York at Binghamton. Binghamton, New York, 1985. With an essay by the artist.
George McNeil: Expressionism, 1954–1984. Exh. cat., Artists' Choice Museum. New York, 1984. With an essay by the artist.
The Paintings of George McNeil. Exh. cat., The University Art Museum, The University of Texas. Austin, 1966. With an essay by the artist.
Russell, John. "George McNeil at 75: Art on the Wild Side." *New York Times* (25 February 1983).

Melissa Meyer

Born:
New York, New York, 1947

Lives:
New York, New York

Education:
New York University, New York, New York, B.S., 1968; M.A., 1975.

Bibliography:
Artists of the 80s: Selected Works from the Maslow Collection. Exh. cat., Sordoni Art Gallery, Wilkes College. Wilkes-Barre, Pennsylvania, 1989: 58–59.
Gaugh, Harry F. *Melissa Meyer.* Exh. brochure, R. C. Erpf Gallery. New York, 1986.
Melissa Meyer: Paintings and Drawings 1980–1984. Exh. cat., Exit Art. New York, 1984. With an essay by Stephen Westfall.
Rubinstein, Meyer Raphael. "Melissa Meyer, with Digressions." *Arts Magazine* 62 (March 1988): 22–23.
Sofer, Ken. "Melissa Meyer at Exit Art." *ARTnews* 84 (February 1985): 138.

Richard Mock

Born:
Long Beach, California, 1944

Lives:
New York, New York

Education:
University of Michigan, Ann Arbor, Michigan, B.S., 1965.
San Francisco Art Institute, San Francisco, California, 1965.
Provincetown Artists' Workshop, Provincetown, Massachusetts, 1964.
New York Studio School of Drawing, Painting and Sculpture, New York, New York, 1965.
Skowhegan School of Painting and Sculpture, Skowhegan, Maine, 1966.

Bibliography:
Cohen, Ronny. "New Editions: Richard Mock." *ARTnews* 82 (April 1983): 84.
Cohrs, Timothy. "Pathos and Prescience and the Paintings of Richard Mock." *Arts Magazine* 60 (Summer 1986), 22–23.
Mock of the Times: 60 Linocuts by Richard Mock Appearing in the Op-Ed Pages of the New York Times, July 23, 1980–April 19, 1986. New York: Mock Studios, 1987.
Paoletti, John T. "Richard Mock." *Arts Magazine* 57 (March 1983): 3.
Schwabsky, Barry. "Richard Mock at Brooke Alexander and Exit Art." *Artscribe* 57 (April–May 1986): 79–80.

Malcolm Morley

Born:
London, England, 1931

Lives:
New York, New York

Education:
Camberwell School of Art and Crafts, London, graduated 1953.
Royal College of Art, London, A.R.C.A., 1957.

Bibliography:
Collings, Matthew. "Malcolm Morley." *Artscribe* 42 (August 1983): 49–55.
Malcolm Morley: New Paintings and Watercolors, 1984–1986. Exh. cat., Xavier Fourcade, Inc. New York, 1986.
Malcolm Morley: New Work. Exh. cat., The Pace Gallery. New York, 1988. With a conversation between Arnold Glimcher and the artist.
Malcolm Morley: Prints & Process. Exh. cat., Pace Prints. New York, 1986.
Yau, John. "Defying Style." *Portfolio* 5 (January–February 1983): 74–77.

Elizabeth Murray

Born:
Chicago, Illinois, 1940

Lives:
New York, New York

Education:
School of the Art Institute of Chicago, Chicago, Illinois, B.F.A., 1962.
Mills College, Oakland, California, M.F.A., 1964.

Bibliography:
Armstrong, Elizabeth, and Sheila McGuire. *First Impressions: Early Prints by Forty-six Contemporary Artists.* Exh. cat., Walker Art Center. Minneapolis, 1989: 114–17.
Brody, Jacqueline. "Elizabeth Murray: Thinking in Print" (an interview with the artist). *The Print Collector's Newsletter* 13 (July–August 1982): 73–77.
Field, Richard S., and Ruth E. Fine. *A Graphic Muse: Prints by Contemporary American Women.* Exh. cat., Mount Holyoke College Art Museum. New York and South Hadley, Massachusetts, 1987: 119–24.
Graze, Sue, Kathy Halbreich, and Roberta Smith. *Elizabeth Murray: Paintings and Drawings.* Exh. cat., Dallas Museum of Art and Massachusetts Institute of Technology. New York: Harry N. Abrams Inc., Publishers, 1987.
Jacobowitz, Ellen S., and Ann Percy. *New Art on Paper.* Exh. cat., Philadelphia Museum of Art. Philadelphia, 1988.

Bruce Nauman

Born:
Fort Wayne, Indiana, 1941

Lives:
Pecos, New Mexico

Education:
University of Wisconsin, Madison, Wisconsin, B.S., 1964.
University of California, Davis, California, M.F.A., 1966.

Bibliography:
Cordes, Christopher. Unpublished interview of 16–17 July 1977 with Bruce Nauman. On file in the archives at Leo Castelli Gallery, New York.
Fine, Ruth E. *Gemini G.E.L.: Art and Collaboration.* Exh. cat., National Gallery of Art. Washington, 1984: 11, 25, 76, 77, 90–92, 209, 238–39, 261.
Sehjeldahl, Peter. "Profoundly Practical Jokes: The Art of Bruce Nauman." *Vanity Fair,* May 1983, 89–93.
van Bruggen, Coosje. *Bruce Nauman.* New York: Rizzoli, 1988.
Wye, Deborah. *Committed to Print.* Exh. cat., The Museum of Modern Art. New York, 1988: 65, 75, 111.

John Newman

Born:
New York, New York, 1952

Lives:
New York, New York

Education:
Whitney Museum of American Art, Independent Study Program, New York, New York, 1972.
Oberlin College, Oberlin, Ohio, B.A., 1973.
Yale University, School of Art and Architecture, New Haven, Connecticut, M.F.A., 1975.

Bibliography:
Cohen, Ronny H. "New Abstraction V." *The Print Collector's Newsletter* 18 (March–April 1987): 9, 11–12.
Kotik, Charlotta. *Monumental Drawing: Works by 22 Contemporary Americans.* Exh. cat., The Brooklyn Museum. Brooklyn, 1986: 32–33.
Saunders, Wade. "Talking Objects: Interviews with Ten Sculptors." *Art in America* 73 (November 1985): 128–29.
Silverman, Andrea. "New Editions." *ARTnews* 85 (October 1986): 97–98.

Hermann Nitsch

Born
Vienna, Austria, 1938

Lives:
Prinzendorf, Austria

Bibliography:
Günter Brus, Hermann Nitsch, Arnulf Rainer: Austrian Drawings. Exh. cat., The Renaissance Society at The University of Chicago. Chicago, 1986: 4–9.
Hermann Nitsch: Works on Paper 1956–1988. Exh. cat., David Nolan Gallery. New York, 1988. With essays by John Paoletti and the artist.
Museum Moderner Kunst, Vienna, and Städtische Galerie im Lenbachhaus, Munich, eds. *Nitsch: Das bildnerische Werk.* Salzburg and Vienna: Residenz Verlag, 1988. With essays by Günter Brus, Ingrid Rein, Dieter Ronte, Armin Zweite, and the artist.
Schiff, Gert. "Frankfurt." *Contemporanea* 2 (June 1989): 16–18.
Wunderlich, Wolfgang. "Zur Druckgrafik von Hermann Nitsch." In *Druckgraphik 1970–85,* edited by Peter Pakesch. Exh. cat., Künstlerhaus Graz, Grazer Kunstverein. Graz, Austria, 1986: 68–71.

Mimmo Paladino

Born:
Paduli, Italy, 1948

Lives:
Milan and Paduli, Italy

Education:
Liceo Artistico di Benevento, Benevento, Italy, 1964–1968.

Bibliography:
Armstrong, Elizabeth, and Marge Goldwater. *Images and Impressions: Painters Who Print.* Exh. cat., Walker Art Center. Minneapolis, 1984: 40–45.
Berger, Danny. ''Mimmo Paladino: An Interview.'' *The Print Collector's Newsletter* 14 (May–June 1983): 48–50.
Butler, Charles T., and Marilyn Laufer. *Recent Graphics from American Print Shops.* Exh. cat., Mitchell Museum. Mount Vernon, Illinois, 1986: 6, 27, 38.
Fox, Howard. *A New Romanticism: Sixteen Artists from Italy.* Exh. cat., Hirshhorn Museum and Sculpture Garden. Washington, 1985: 83–85, 118–20.
Mimmo Paladino: Etchings, woodcuts and linocuts 1983–86. Exh. cat., Dolan/Maxwell Gallery. Philadelphia, 1986. With an essay by Richard E. Caves.

Jürgen Partenheimer

Born:
Munich, Federal Republic of Germany, 1947

Lives:
Düsseldorf, Federal Republic of Germany

Education:
University of Arizona, Tucson, Arizona, M.F.A., 1974.
University of Munich, PhD., 1975.

Bibliography:
Haase, Amine. ''Jürgen Partenheimer: Wanderer Between the Worlds.'' *Parkett* 12 (1987): 22–31.
Jürgen Partenheimer: Verwandlung—Heimkehr. West Berlin: Nationalgalerie Berlin, 1988. With essays by Maria Kreutzer, Jürgen Partenheimer, Mathilde Roskam, Britta Schmitz, Peter Selz, and Michael Semff.
Partenheimer, Jürgen. *Der Ort des Bogens (The Site of the Bow).* Münster: Westfälischer Kunstverein, 1984.
Partenheimer, Jürgen. *Der Weg der Nashörner AXIS MUNDI twixt thumb and the next.* Munich: Kunstraum München, 1983.
Pejic, Bojana. ''Jürgen Partenheimer: Wanderings.'' *Artforum* 27 (December 1988): 74–78.

A. R. Penck

Born:
Dresden, Germany, 1939

Lives:
London, England

Bibliography:
A. R. Penck. Exh. cat., Nationalgalerie Berlin, Staatliche Museen Preussischer Kulturbesitz. Berlin, 1988. With essays by Lucius Grisebach, Thomas Kirchner, and others, and a poem by the artist.
A. R. Penck Graphik Ost/West. Exh. cat., Kunstverein Braunschweig. Brunswick, 1985. With an introduction by Wilhelm Bojescul.
A. R. Penck: Holzschnitte 1966–1987, Exh. cat., Gerhard Marcks-Haus. Bremen, 1988. With an essay by Martina Rudloff.
A. R. Penck: Zeichnungen und druckgraphische Werke im Basler Kupferstichkabinett. Exh. cat., Kunstmuseum Basel. Basel, 1986.
Dietrich, Dorothea. ''A Talk with A. R. Penck.'' *The Print Collector's Newsletter* 14 (July–August 1983): 91–95.

Howardena Pindell

Born:
Philadelphia, Pennsylvania, 1943

Lives:
New York, New York

Education:
Boston University, Boston, Massachusetts, B.F.A., 1965.
Yale University, School of Art and Architecture, New Haven, Connecticut, M.F.A., 1967.

Bibliography:
Field, Richard S., and Ruth E. Fine. *A Graphic Muse: Prints by Contemporary American Women.* Exh. cat., Mount Holyoke College Art Museum. New York and South Hadley, Massachusetts, 1987: 129–32.
Howardena Pindell/Matrix 105. Exh. brochure, Wadsworth Atheneum. Hartford, 1989. With an essay by Andrea Miller-Keller.
Howardena Pindell: Odyssey. Exh. cat., The Studio Museum in Harlem. New York, 1986. With an essay by Terrie S. Rouse.
Jacobowitz, Ellen S., and Ann Percy. *New Art on Paper.* Exh. cat., Philadelphia Museum of Art. Philadelphia, 1988: 42–43, 67.
Miller, Lynn F. and Sally S. Swenson. *Lives and Works: Talks with Women Artists.* Metuchen, N. J.: The Scarecrow Press, Inc., 1981, 130–56.

Arnulf Rainer

Born:
Baden, Austria, 1929

Lives:
Vienna, Upper Austria and Bavaria

Bibliography:
Arnulf Rainer: Fingermalereien (1975–1984), Christus—Frauen—Tote (1982–1984). Exh. cat., Galerie für Film, Foto, Neue Konkrete Kunst und Video. Bochum, Federal Republic of Germany, 1984. With essays by the artist and Konrad Schmidt, and an interview of the artist by Friedhelm Mennekes.
Fuchs, R. H. *Arnulf Rainer.* Exh. cat., The Solomon R. Guggenheim Museum. New York, 1989.
Gachnang, Johannes. ''Broodthaers / Roth / Johns / Rainer / LeWitt / Kirkeby.'' In *Druckgraphik 1970–85,* edited by Peter Pakesch. Exh. cat., Künstlerhaus Graz, Grazer Kunstverein. Graz, Austria, 1986: 9–35.
Paoletti, John T. ''Arnulf Rainer: Prints as Encounter & Event.'' *The Print Collector's Newsletter* 18 (March–April 1987): 1–6.
Radierungen im 20. Jahrhundert. Exh. cat., Staatsgalerie Stuttgart. Stuttgart, 1987: 58, 216–19. With essays by Hans-Martin Kaulbach and Michael Scholz-Hänsel.

Robert Rauschenberg

Born:
Port Arthur, Texas, 1925

Lives:
Captiva Island, Florida

Education:
Kansas City Art Institute, Kansas City, Missouri, 1947–1948.
Académie Julien, Paris, France, 1947.
Black Mountain College, Black Mountain, North Carolina, 1948–1949.
Art Students League of New York, New York, New York, 1949–1951.

Bibliography:
Bernstock, Judith E. ''A New Interpretation of Rauschenberg's Imagery.''
 Pantheon 46 (1988): 149–64.
Fine, Ruth E. *Gemini G.E.L.: Art and Collaboration.* Exh. cat., National
 Gallery of Art. Washington, 1984: 105–25, 263.
Forge, Andrew. *Rauschenberg.* New York: Harry N. Abrams, 1969.
Rauschenberg Werke 1950–1980. Exh. cat., Staatliche Kunsthalle. Berlin,
 1980. With essays by Lawrence Alloway and Götz Adriani.
Tomkins, Calvin. *Off the Wall: Robert Rauschenberg and the Art World of
 of Our Time.* New York: Doubleday & Co., Inc., 1980.

Susan Rothenberg

Born:
Buffalo, New York, 1945

Lives:
New York, New York

Education:
Cornell University, Ithaca, New York, B.F.A., 1967.

Bibliography:
Field, Richard S., and Ruth E. Fine. *A Graphic Muse: Prints by Contempo-
 rary American Women.* Exh. cat., Mount Holyoke College Art Museum.
 New York and South Hadley, Massachusetts, 1987: 139–43.
Glueck, Grace. ''Susan Rothenberg: New Outlook for a Visionary Artist.''
 The New York Times Magazine (22 July 1984).
Armstrong, Elizabeth, and Marge Goldwater. *Images and Impressions:
 Painters Who Print.* Exh. cat., Walker Art Center. Minneapolis, 1984:
 46–51.
Maxwell, Rachel Robertson. *Susan Rothenberg: The Prints. A Catalogue
 Raisonné.* Philadelphia: Peter Maxwell, 1987.
Rathbone, Eliza. *Susan Rothenberg.* Exh. cat., Phillips Collection. Wash-
 ington, 1985.

Edward Ruscha

Born:
Omaha, Nebraska, 1937

Lives:
Los Angeles, California

Education:
Chouinard Art Institute, Los Angeles, California, 1956–1960.

Bibliography:
Fine, Ruth E. *Gemini G.E.L.: Art and Collaboration.* Exh. cat., National
 Gallery of Art. Washington, 1984: 11, 21, 38, 76, 92–93, 209,
 232–234, 265.
Graphic Works by Edward Ruscha. Exh. cat., Auckland City Art Gallery.
 Auckland, 1978. With an essay by Andrew Bogle.
The Works of Edward Ruscha. Exh. cat., San Francisco Museum of Mod-
 ern Art. San Francisco, 1982. With essays by Anne Livet, Dave Hickey,
 and Peter Plagens.
Zeichnungen von Edward Ruscha. Westfälischer Kunstverein. Münster,
 1986. With an essay by Marianne Stockebrand.
Words Without Thoughts Never to Heaven Go. Exh. cat., Lannan
 Museum. Lake Worth, 1988. New York: Harry N. Abrams, 1988.
 With essays by Bonnie Clearwater and Christopher Knight.

David Salle

Born:
Norman, Oklahoma, 1952

Lives:
New York, New York

Education:
California Institute of the Arts, Valencia, California, B.F.A., 1973; M.F.A.,
 1975.

Bibliography:
David Salle. Exh. cat., Fundación Caja de Pensiones. Madrid, 1988. With
 essays by Kevin Power and Carla Schulz-Hoffmann.
Field, Richard S. ''David Salle.'' In *Contemporary American Artists in Print:
 Eric Fischl, Jenny Holzer, Barbara Kruger, Susan Rothenberg & David
 Salle.* Exh. cat., Yale University Art Gallery. New Haven, 1987.
Kardon, Janet, and Lisa Phillips. *David Salle.* Exh. cat., Institute of Con-
 temporary Art, University of Pennsylvania. Philadelphia, 1986.
Ratcliff, Carter. ''David Salle's Aquatints.'' *The Print Collector's Newsletter*
 13 (September–October 1982): 123–26.
Schjeldahl, Peter. *Salle* (an interview with the artist). Elizabeth Avedon
 Editions: Vintage Contemporary Artists. New York: Vintage Books,
 1987.

Sean Scully

Born:
Dublin, Ireland, 1945

Lives:
New York, New York

Education:
Croydon College of Art, London, England, 1965–1968.
Newcastle University, Newcastle upon Tyne, England, Fine Arts Degree,
 1971.
Department of Fine Arts, Harvard University, Cambridge, Massachusetts,
 Knox Fellowship, 1972–1973.

Bibliography:
Caldwell, John, David Carrier, and Amy Lighthill. *Sean Scully.* Exh. cat.,
 Museum of Art, Carnegie Institute. Pittsburgh, 1985.
Lewallen, Constance. ''Sean Scully'' (an interview with the artist). *View* 5
 (Fall 1988). Published by Crown Point Press, San Francisco.
Sean Scully: Paintings 1985–1986. Exh. cat., David McKee Gallery. New
 York, 1986. With a conversation between Joseph Masheck and the
 artist.
Sean Scully: Paintings & Works on Paper 1982–88. Exh. cat., Whitecha-
 pel Art Gallery. London, 1989. With an essay by Carter Ratcliff.
Silverman, Andrea. ''New Editions.'' *ARTnews* 85 (October 1986):
 98–99.

Joel Shapiro

Born:
New York, New York, 1941

Lives:
New York and Westport, New York

Education:
New York University, New York, New York, B.A., 1964; M.A., 1969.

Bibliography:
Bass, Ruth. "Minimalism Made Human." *ARTnews* 86 (March 1987): 94–101.

Joel Shapiro. Exh. cat., Whitney Museum of American Art. New York, 1982. With an essay by Roberta Smith.

Ormond, Mark. *Joel Shapiro: Sculpture and Drawings 1981–85*. Exh. cat., The John and Mable Ringling Museum of Art. Sarasota, Florida, 1986.

Princenthal, Nancy. "Against the Grain: Joel Shapiro's Prints." *The Print Collector's Newsletter* 20 (September–October 1989): 121–24.

Walker, Barry. *Public and Private: American Prints Today; the 24th National Print Exhibition*. Exh. cat., The Brooklyn Museum. Brooklyn, 1986: 115.

Joan Snyder

Born:
Highland Park, New Jersey, 1940

Lives:
Eastport, New York

Education:
Rutgers, The State University of New Jersey, Douglass College, New Brunswick, New Jersey, B.A., 1962.

Rutgers, The State University of New Jersey, New Brunswick, New Jersey, M.F.A., 1966.

Bibliography:
Field, Richard S., and Ruth E. Fine. *A Graphic Muse: Prints by Contemporary American Women*. Exh. cat., Mount Holyoke College Art Museum. New York and South Hadley, Massachusetts, 1987: 148–52.

Herrera, Hayden. *Joan Snyder: Seven Years of Work*. Exh. cat., Neuberger Museum, State University of New York at Purchase. Purchase, New York, 1978.

Tarlow, Lois. "Profile: Joan Snyder." *Art New England* 8 (February 1987): 14–15, 22.

Webster, Sally. "Joan Snyder, Fury and Fugue: Politics of the Inside." *The Feminist Art Journal* 5 (Summer 1976), 5–8.

Michael Walls. *Joan Snyder*. Exh. cat., San Francisco Art Institute. San Francisco, 1979.

T. L. Solien

Born:
Fargo, North Dakota, 1949

Lives:
Pelican Rapids, Minnesota

Education:
Moorhead State University, Moorhead, Minnesota, B.A., 1973.
University of Nebraska, Lincoln, Nebraska, M.F.A., 1977.

Bibliography:
Armstrong, Elizabeth, and Sheila McGuire. *First Impressions: Early Prints by Forty-six Contemporary Artists*. Exh. cat., Walker Art Center. Minneapolis, 1989: 124–25.

Goldwater, Marge. "T. L. Solien." In Elizabeth Armstrong and Marge Goldwater, *Images and Impressions: Painters Who Print*. Exh. cat., Walker Art Center. Minneapolis, 1984, 52–57.

Heartney, Eleanor. "T. L. Solien." *Arts Magazine* 57 (May 1983): 16.

Paine, Sylvia. "T. L. Solien." *A.R.T.S.* (Monthly Magazine of the Minneapolis Institute of Arts) 8 (August 1985), 24–25.

Rian, Jeffery. "T. L. Solien." *Arts Magazine* 60 (September 1985): 11.

Steven Sorman

Born:
Minneapolis, Minnesota, 1948

Lives:
Marine on St. Croix, Minnesota

Education:
University of Minnesota, Minneapolis, Minnesota, B.F.A., 1971.

Bibliography:
Adams, Clinton. "Leading into the Work: A Conversation about Making Prints." *The Tamarind Papers* 10 (Spring 1987): 4–15.

Armstrong, Elizabeth, and Sheila McGuire. *First Impressions: Early Prints by Forty-six Contemporary Artists*. Exh. cat., Walker Art Center. Minneapolis, 1989, 102–03.

Hampl, Patricia. *Steven Sorman*. Exh. cat., Dolan/Maxwell Gallery. Philadelphia, 1986.

Larson, Philip. "Steven Sorman: An Interview." *The Print Collector's Newsletter* 11 (May–June 1980): 42–44.

Riddle, Mason. "Steven Sorman: New Monoprints & Variant Editions." *The Print Collector's Newsletter* 16 (March–April 1985): 11–12.

Pat Steir

Born:
Newark, New Jersey, 1940

Lives:
New York, New York; Amsterdam, Netherlands

Education:
Boston University, Boston, Massachusetts, 1958–1960.
Pratt Institute, School of Art and Design, Brooklyn, New York, B.F.A., 1962.

Bibliography:
Broun, Elizabeth. *Form, Illusion, Myth: Prints and Drawings of Pat Steir*. Exh. cat., Spencer Museum of Art, The University of Kansas. Lawrence, Kansas, 1983.

Castle, Frederick Ted. "Pat Steir: Ways of Marking." *Art in America* 72 (Summer 1984): 124–29.

Field, Richard S., and Ruth E. Fine. *A Graphic Muse: Prints by Contemporary American Women*. Exh. cat., Mount Holyoke College Art Museum. New York and South Hadley, Massachusetts, 1987: 153–57.

Ratcliff, Carter. *Pat Steir Paintings*. New York: Harry N. Abrams Co., 1986.

White, Robin. "Pat Steir" (an interview with the artist). *View* 1 (June 1978). Published by Crown Point Press, Oakland.

Frank Stella

Born:
Malden, Massachusetts, 1936

Lives:
New York, New York

Education:
Princeton University, Princeton, New Jersey, B.A., 1958.

Bibliography:
Axsom, Richard H. "Frank Stella at Bedford." in Tyler Graphics: The Extended Image. Minneapolis: Walker Art Center; New York, Abbeville Press Publishers, 1987: 161–87.
Axsom, Richard H. The Prints of Frank Stella: A Catalogue Raisonné 1967–1982. New York: Hudson Hills Press, 1983.
Meier, Richard. 'Shards' by Frank Stella. New York: Petersburg Press, 1983.
Rubin, William. Frank Stella 1970–1987. Exh. cat., The Museum of Modern Art. New York, 1987.
Stella, Frank. Working Space. Cambridge, Massachusetts: Harvard University Press, 1986.

David Storey

Born:
Madison, Wisconsin, 1948

Lives:
New York, New York

Education:
University of California, Berkeley, California, 1966–1968.
University of California, Davis, California, B.A., 1970; M.F.A., 1972.

Bibliography:
Adams, Brooks. "David Storey at Concord." Art in America 71 (October 1983): 181.
Drawings by Painters. Exh. cat., Long Beach Museum of Art. Long Beach, California, 1982: 14, 23, 58, 77. With an essay by Richard Armstrong.
Liebmann, Lisa. "M.B.A. Abstractionism." Flash Art 132 (February–March 1987): 86–89.
Lurie, David. "David Storey." Arts Magazine 60 (December 1985): 118.
Westfall, Stephen. "David Storey at Jay Gorney." Art in America 74 (April 1986): 190–91.

Donald Sultan

Born:
Asheville, North Carolina, 1951

Lives:
New York, New York

Education:
University of North Carolina, Chapel Hill, North Carolina, B.F.A., 1973.
School of the Art Institute of Chicago, Chicago, Illinois, M.F.A., 1975.

Bibliography:
Donald Sultan. Exh. cat., Blum Helman Gallery. New York, 1984.
Donald Sultan Prints 1979–1985. Exh. cat., Barbara Krakow Gallery. Boston, 1985.
Dunlop, Ian, and Lynne Warren. Donald Sultan. Exh. cat., Museum of Contemporary Art. Chicago, 1987.
Henry, Gerrit. "Donald Sultan: His Prints." The Print Collector's Newsletter 16 (January–February 1986): 193–96.
Rose, Barbara. Sultan (an interview with the artist). Elizabeth Avedon Editions: Vintage Contemporary Artists. New York: Vintage Books, 1988.

James Turrell

Born:
Los Angeles, California, 1943

Lives:
Flagstaff, Arizona and Santa Monica, California

Education:
Pomona College, Claremont, California, B.A., 1965.
University of California, Irvine, California, 1965–1966.
Claremont Graduate School, Claremont, California, M.A., 1973.

Bibliography:
Adcock, Craig, and John Russell. James Turrell: The Roden Crater Project. Exh. cat., University of Arizona Museum of Art. Tucson, 1986.
Armstrong, Elizabeth, and Sheila McGuire. First Impressions: Early Prints by Forty-six Contemporary Artists. Exh. cat., Walker Art Center. Minneapolis, 1989: 132–33.
Peter Blum Edition New York II. Exh. cat., Groninger Museum. Groningen, Netherlands, 1985: 4–6, 32–35. With an essay by Steven Kolsteren.
Mapping Spaces: A Topological Survey of the Work by James Turrell. New York: Peter Blum Edition, 1987. With essays by Craig Adcock, Jean-Christophe Ammann, Mario Diacono, and E. C. Krupp.
Ratcliff, Carter. "James Turrell's 'Deep Sky'." The Print Collector's Newsletter 16 (May–June 1985): 45–47.

Richard Tuttle

Born:
Rahway, New Jersey, 1941

Lives:
New York, New York

Education:
Pratt Institute, School of Art and Design, Brooklyn, New York, 1962.
Trinity College, Hartford, Connecticut, B.A., 1963.
Cooper Union for the Advancement of Science and Art, New York, New York, 1963–1964.

Bibliography:
Richard Tuttle. Exh. cat., Städtisches Museum Abteiberg. Mönchengladbach, Federal Republic of Germany, 1985. With essays by Dierk Stemmler and the artist.
Richard Tuttle: Wire Pieces. Exh. cat., Musée d'art contemporain. Bordeaux, 1986. With essays by the artist and others and an interview of the artist by Sylvie Couderc.
Tucker, Marcia. Richard Tuttle. Exh. cat., Whitney Museum of American Art. New York, 1975.

Not Vital

Born:
Sent, Switzerland, 1948

Lives:
New York, New York; Lucca, Italy

Education:
Centre Universitaire Expérimental de Vincennes, Paris, France, 1968–1971.

Bibliography:
Cotter, Holland. "Not Vital at Curt Marcus." *Art in America* 76 (October 1988): 193.

Iannacci, Anthony. "Salvatore Scarpitta, Not Vital: Studio Guenzani." *Artscribe* 71 (September–October 1988): 98.

Kunz, Martin, ed. *Not Vital*. Exh. cat., Kunstmuseum Luzern. Lucerne, 1988. With an essay by Matthias Frehner.

Kuspit, Donald. "Not Vital's Relics of the Present." *Artforum* 27 (January 1989): 88–91.

Tallman, Susan. "Sound and Vision: Multiples by Not Vital and Christian Marclay." *Arts Magazine* 63 (May 1989): 17–18.

William T. Wiley

Born:
Bedford, Indiana, 1937

Lives:
Forest Knolls, California

Education:
San Francisco Art Institute, San Francisco, California, B.F.A., 1960; M.F.A., 1962.

Bibliography:
Armstrong, Elizabeth, and Sheila McGuire. *First Impressions: Early Impressions by Forty-six Contemporary Artists*. Exh. cat., Walker Art Center. Minneapolis, 1989: 86–88.

Beal, Graham W. J., and John Perreault. *Wiley Territory*. Exh. cat., Walker Art Center. Minneapolis, 1979.

Cebulski, Frank. "Sculptors as Printmakers." *Artweek* 13 (28 August 1982): 16.

White, Robin. "William T. Wiley" (an interview with the artist). *View* 2 (May 1979). Published by Crown Point Press, Oakland.

Terry Winters

Born:
Brooklyn, New York, 1949

Lives:
New York, New York

Education:
Pratt Institute, School of Art and Design, Brooklyn, New York, B.F.A., 1971.

Bibliography:
Ackley, Clifford S. "'Double Standard': The Prints of Terry Winters." *The Print Collector's Newsletter* 18 (September–October 1987): 121–24.

Armstrong, Elizabeth, and Sheila McGuire. *First Impressions: Early Prints by Forty-six Contemporary Artists*. Exh. cat., Walker Art Center. Minneapolis, 1989: 126–27.

Dunham, Judith. *The Monumental Image*. Exh. cat., University Art Gallery, Sonoma State University. Rohnert Park, California, 1987: 18–19, 26–28, 31.

Plous, Phyllis. *Terry Winters: Painting and Drawing*. Exh. cat., University Art Museum, University of California. Santa Barbara, 1987.

Terry Winters. Exh. cat., Kunstmuseum Luzern. Lucerne, 1985. With essays by Martin Kunz and Klaus Kertess.

Troels Wörsel

Born:
Aarhus, Denmark, 1950

Lives:
Cologne, Federal Republic of Germany

Bibliography:
Kren, Alfred. "Methods, But No System: Aspects of Recent Drawing in Europe." *Drawing* 5 (November–December 1983): 83–86.

Kuspit, Donald B. "Painting to Satiety: Franz Hitzler and Troels Wörsel." *Arts Magazine* 57 (February 1983): 86–87.

Bernd Zimmer

Born:
Planegg, Federal Republic of Germany, 1948

Lives:
Polling, Federal Republic of Germany

Education:
Kunsthistorisches Institut der Freien Universität, West Berlin, 1973–1979

Bibliography:
Bernd Zimmer: Bilder-Landschaften 1983–1985. Exh. cat., Kunstverein Braunschweig. Brunswick, 1986. With essays by Dorothée Bauerle, Wilhelm Bojescul, Roland Simon-Schaefer, and Beat Wyss.

General Bibliography

The Print Collector's Newsletter, which has been published since 1970 to the present, is the most useful reference on prints of this period and their immediate background.

Selected Books and Periodicals

Ackley, Clifford S., Thomas Krens, and Deborah Menaker. *The Modern Art of the Print: Selections from the Collection of Lois and Michael Torf.* Exh. cat., Williams College Museum of Art and Museum of Fine Arts. Williamstown and Boston, Massachusetts, 1984.

Ackley, Clifford S. *70s into 80s: Printmaking Now.* Exh. cat., Museum of Fine Arts. Boston, 1986.

_____. "The Unique Print." *Art New England* 10 (March 1989): 5–7, 30.

American Print Renaissance 1958–1988. Exh. cat., Whitney Museum of American Art, Fairfield County. Stamford, Connecticut, 1988.

Armstrong, Elizabeth, and Marge Goldwater. *Images and Impressions: Painters Who Print.* Exh. cat., Walker Art Center. Minneapolis, 1984.

Armstrong, Elizabeth, and Sheila McGuire. *First Impressions: Early Prints by Forty-six Contemporary Artists.* Exh. cat., Walker Art Center. Minneapolis, 1989.

Baro, Gene. *Thirty Years of American Printmaking.* Exh. cat., The Brooklyn Museum. Brooklyn, 1977.

_____. *Twenty-Second National Print Exhibition.* Exh. cat., The Brooklyn Museum. Brooklyn, 1981.

Beal, Graham W. J. *Artist and Printer: Six American Print Studios.* Exh. cat., Walker Art Center. Minneapolis, 1980.

Big Prints. Exh. cat., Arts Council of Great Britain. London, 1982. With an essay by Frances Carey.

Butler, Charles T., and Marilyn Laufer. *Recent Graphics from American Print Shops.* Exh. cat., Mitchell Museum. Mount Vernon, Illinois, 1986.

Castleman, Riva. *Printed Art: A View of Two Decades.* Exh. cat., The Museum of Modern Art. New York, 1980.

_____. *Prints from Blocks: Gauguin to Now.* New York: The Museum of Modern Art, 1983.

_____. *American Impressions: Prints Since Pollock.* New York: Alfred A. Knopf, 1985.

Cohen, Ronny. "Paper Routes." *ARTnews* 82 (October 1983): 78–85.

_____. "Jumbo Prints: Artists Who Paint Big Want to Print Big." *ARTnews* 83 (October 1984): 80–87.

Cohrs, Timothy. "Hudson River Editions, Pelavin Editions—A Report Back From the Other-World of Printmaking." *Arts Magazine* 61 (November 1986): 41–43.

The Combination Print: 1980s. Exh. cat., New Jersey Center for Visual Arts. Summit, New Jersey, 1988. With an essay by Barry Walker.

Contemporary American Monotypes. Exh. cat., The Chrysler Museum. Norfolk, Virginia, 1985. With an essay by Roger D. Clisby.

De Domizio, Lucrezia. "Jorg Schellmann." *Contemporanea* 2 (June 1989): 68–71.

Der deutsche Holzschnitt im 20. Jahrhundert. Exh. cat., Instituts für Auslandsbeziehungen. Stuttgart, 1984. With an essay by Gunther Thiem.

D'Oench, Ellen G., ed. *Collaboration Printmaking Today.* Exh. cat., Davison Art Center, Wesleyan University. Middletown, Connecticut, 1987.

Druckgraphik: Wandlungen eines Mediums seit 1945. Exh. cat., Staatliche Museen Preussischer Kulturbesitz. West Berlin, 1981. With an essay by Alexander Dückers.

Dückers, Alexander. *Von Beuys bis Stella.* Exh. cat., Staatliche Museen Preussischer Kulturbesitz. West Berlin, 1986.

Field, Richard S., and Daniel Rosenfeld. *Prints by Contemporary Sculptors.* Exh. cat., Yale University Art Gallery. New Haven, 1982.

Field, Richard S., and Ruth E. Fine. *A Graphic Muse: Prints by Contemporary American Women.* Exh. cat., Mount Holyoke College Art Museum. New York and South Hadley, Massachusetts, 1987.

Fine, Ruth E. *Gemini G.E.L.: Art and Collaboration.* Exh. cat., National Gallery of Art. Washington, 1984.

Gilmour, Pat. *The Mechanized Image: An Historical Perspective on Twentieth Century Prints.* Exh. cat., Arts Council of Great Britain. London, 1978.

_____. *Ken Tyler, Master Printer; and the American Print Renaissance.* New York: Hudson Hills Press, in association with the Australian National Gallery, 1986.

_____, ed. *Lasting Impressions: Lithography as Art.* London: Alexandria Press, 1988.

Goldman, Judith. "Printmaking: The Medium *isn't* the message anymore." *ARTnews* 79 (March 1980), 82–85.

_____. *American Prints: Process and Proofs.* Exh. cat., Whitney Museum of American Art. New York, 1981.

_____. "Woodcuts: A Revival?," *Portfolio* 4 (November–December 1982): 66–71.

Herrera, Hayden, Sarah McFadden, Carter Ratcliff, and Joan Simon. "Expressionism Today: An Artists' Symposium." *Art in America* 70 (December 1982): 58–75, 139, 141. Interviews with various artists, including Richard Bosman, Eric Fischl, Bill Jensen, Malcolm Morley, Susan Rothenberg, David Salle, Joan Snyder, and Pat Steir.

Jacobowitz, Ellen S., and Ann Percy. *New Art on Paper.* Exh. cat., Philadelphia Museum of Art. Philadelphia, 1988.

The Monumental Image. Exh. cat., University Art Gallery, Sonoma State University. Rohnert Park, California, 1987. With an essay by Judith Dunham.

Newland, Amy Reigle. *Paperworks from Tyler Graphics.* Exh. cat., Walker Art Center. Minneapolis, 1985.

Nine Printmakers and the Working Process. Exh. cat., Whitney Museum of American Art, Fairfield County. Stamford, Connecticut, 1985. With an essay by Pamela Gruninger Perkins.

Peter Blum Edition New York—II: Cucchi, Fischl, Kruger, Stalder, Turrell. Exh. cat., Groninger Museum. Groningen, Netherlands, 1985. With an essay by Steven Kolsteren.

Pakesch, Peter, ed., *Druckgraphik 1970–85.* Exh. cat., Künstlerhaus Graz, Grazer Kunstverein. Graz, Austria, 1986.

Parasol and Simca: Two Presses/Two Processes. Exh. cat., The Center Gallery, Bucknell University. Lewisburg, Pennsylvania, 1984. With an essay by Lizbeth Marano.

Phillips, Deborah C. "Looking for Relief? Woodcuts are Back." *ARTnews* 81 (April 1982): 92–96.

Radierungen im 20. Jahrhundert. Exh. cat., Staatsgalerie Stuttgart. Stuttgart, 1987. With essays by Ulrike Gauss, Michael Scholz-Hänsel, Christian Schneegass, Hans-Martin Kaulbach, and Renate Hauff.

The Rutgers Archives for Printmaking Studios. Exh. cat., The Jane Voorhees Zimmerli Art Museum, Rutgers University. New Brunswick, New Jersey, 1983. With an introduction by Phillip Dennis Cate and an essay by Jeffrey Wechsler.

Sacilotto, Deli, and Donald Saff. *Printmaking: History and Process.* New York: Holt, Rinehart and Winston, 1978.

Saff, Donald, ed. "Printmaking the Collaborative Art." *Art Journal* 39 (Spring 1980): 167–201. This issue is devoted to printmaking, with articles by Garo Z. Antreasian, Karen F. Beall, Kathan Brown, Susie Hennessy, and Alison G. Stewart.

Servis, Nancy M. *Process and Print.* Exh. cat., Sarah Lawrence College Art Gallery. Bronxville, New York, 1988.

Smagula, Howard J. "Printmaking: Art in the Age of Mechanical Reproduction." In *Currents: Contemporary Directions in the Visual Arts.* Englewood Cliffs, New Jersey, 1983: 99–133.

Stasik, Andrew, ed. *Print Review* 13. (1981). With articles by Margot Lovejoy and Carol Saft, among others.

Stein, Donna. "Photography in Printmaking." *Print Review* (1983): 4–20.

Stretch, Bonnie Barrett. "Prints and Photographs: A Rich Mix of Mediums." *ARTnews* 87 (February 1988): 56, 62.

Tallman, Susan. "The Woodcut in the Age of Mechanical Reproduction." *Arts Magazine* 65 (January 1989): 21–22.

Tyler Graphics: The Extended Image. Minneapolis: Walker Art Center; New York: Abbeville Press, 1987. With an introduction by Martin Friedman and essays by Elizabeth Armstrong, Richard H. Axsom, Ruth E. Fine, Jack Flam, Judith Goldman, E. C. Goossen, Robert M. Murdock, and Leonard B. Schlosser.

Vermillion Publications 1978–1983. Minneapolis: Vermillion Editions Ltd., 1983.

Volmer, Suzanne. "Drawings and Prints: As the Twain Meet." *Arts Magazine* 57 (February 1983): 84–85.

Walker, Barry. "The Single State." *ARTnews* 83 (March 1984): 60–65.

_____. *The American Artist as Printmaker: 23rd National Print Exhibition.* Exh. cat., The Brooklyn Museum. Brooklyn, 1983.

_____. *Public and Private: American Prints Today; The 24th National Print Exhibition.* Exh. cat., The Brooklyn Museum. Brooklyn, 1986.

Watrous, James. *A Century of American Printmaking.* Madison: University of Wisconsin Press, 1984.

Wye, Deborah. *Committed to Print.* Exh. cat., The Museum of Modern Art. New York, 1988.

Index of Titles